Extra Extraordinary Chickens

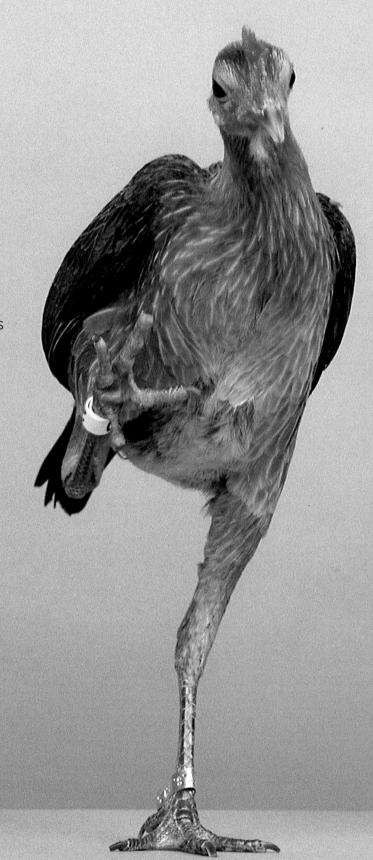

extra
extraordinary
chickens

Stephen Green-Armytage

Abrams, New York

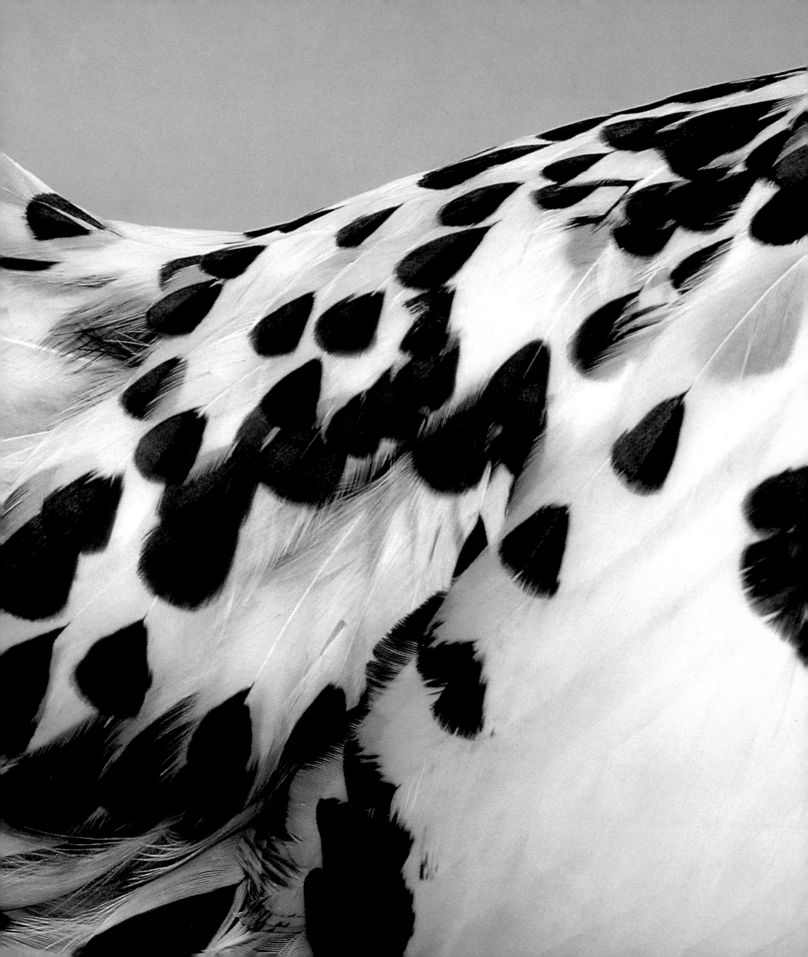

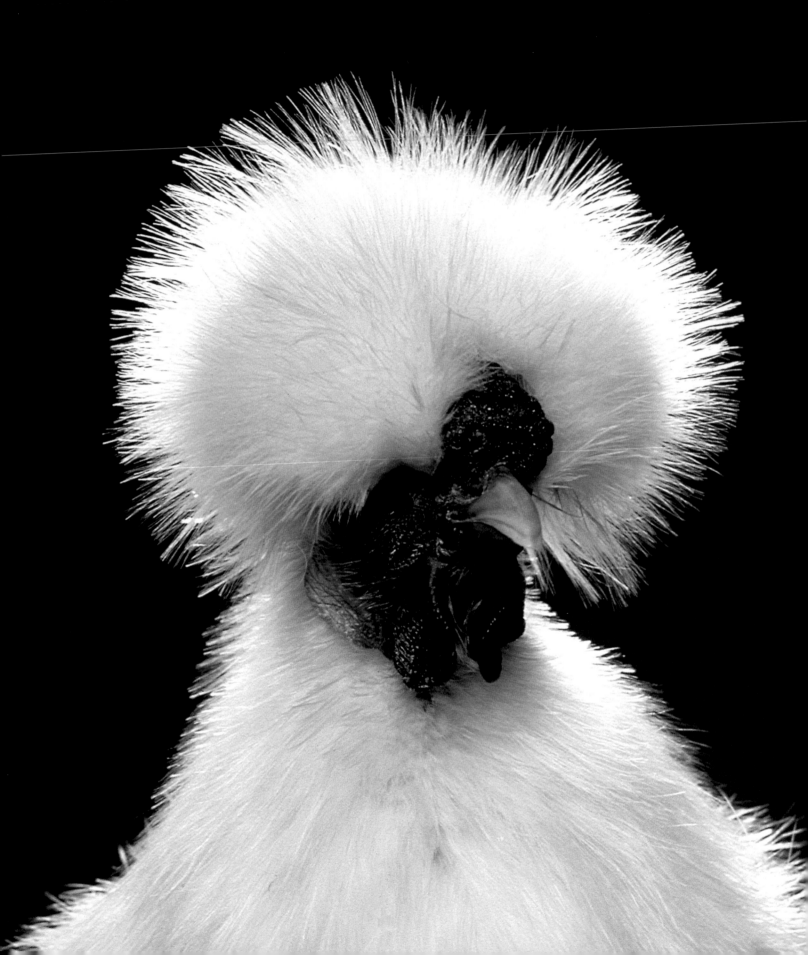

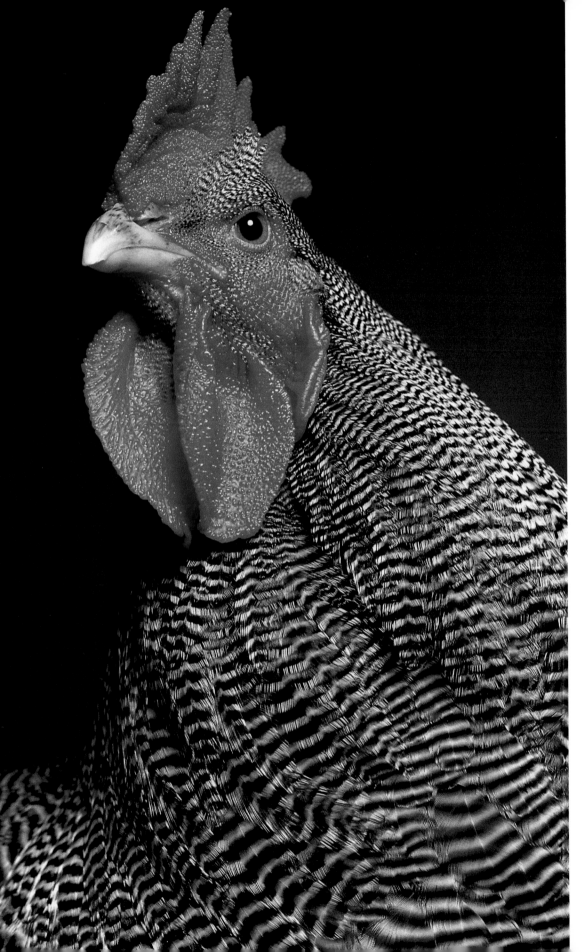

opposite:
SILKIE> NON-BEARDED WHITE

left:
PLYMOUTH ROCK> BARRED

overleaf:
OLD ENGLISH GAME> BLUE-
BREASTED RED COCKEREL

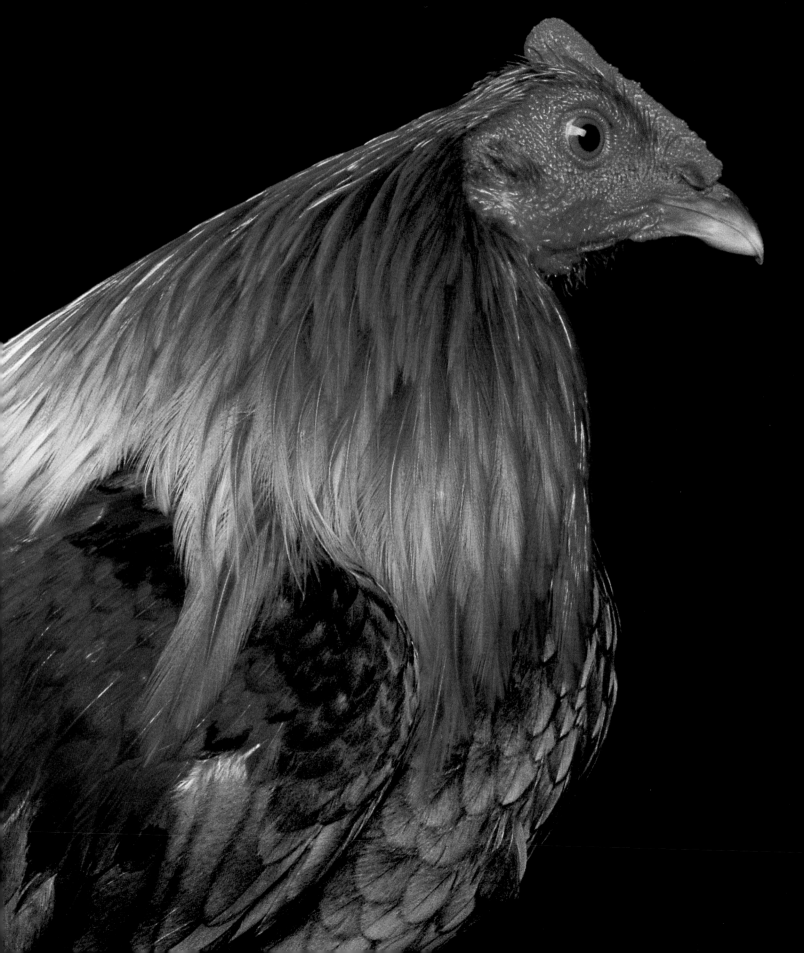

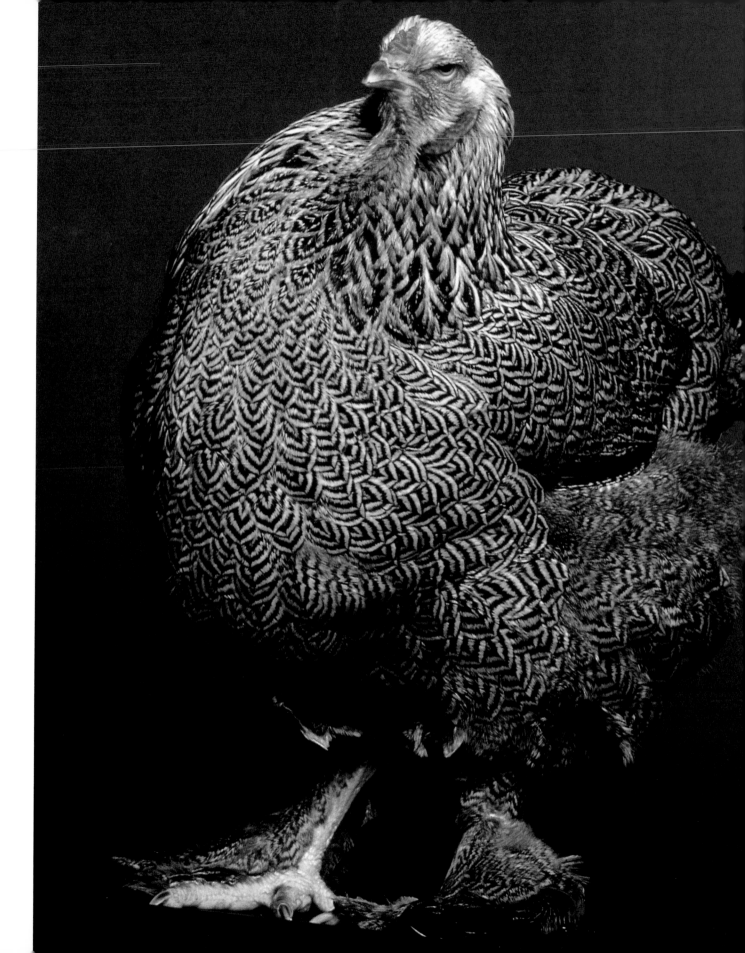

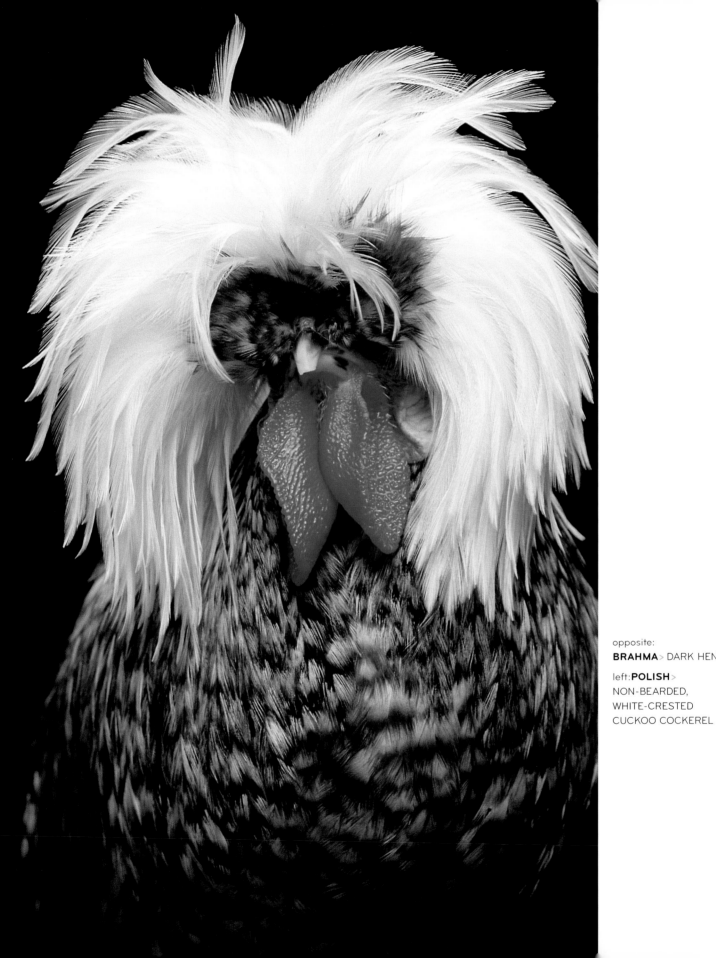

opposite:
BRAHMA> DARK HEN

left:**POLISH**>
NON-BEARDED,
WHITE-CRESTED
CUCKOO COCKEREL

CONTENTS

right: **NAKED NECK FRIZZLE>**
WHITE HEN

overleaf:
AMERICAN POULTRY
ASSOCIATION NATIONAL SHOW,
FAIR GROUNDS, SYRACUSE, NY

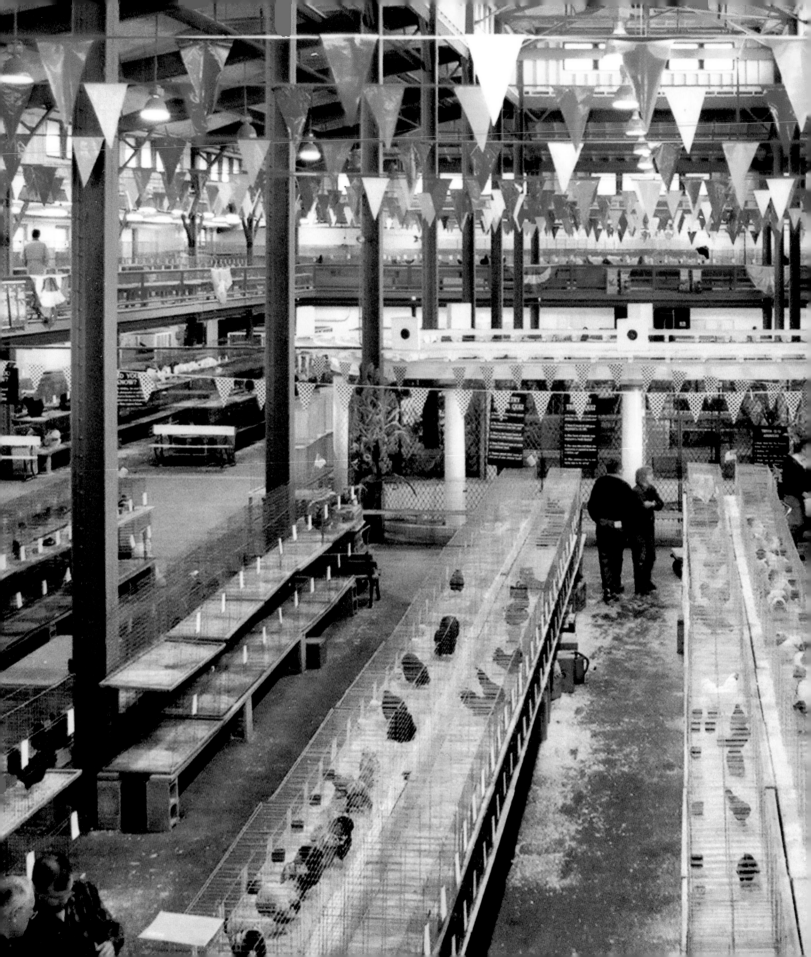

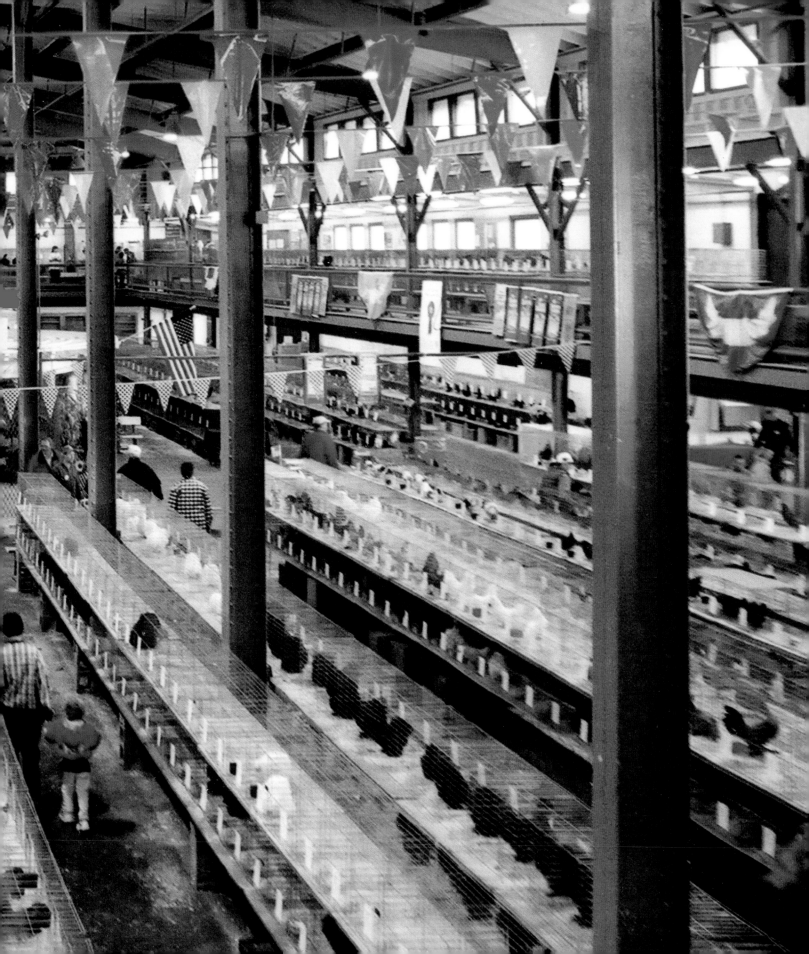

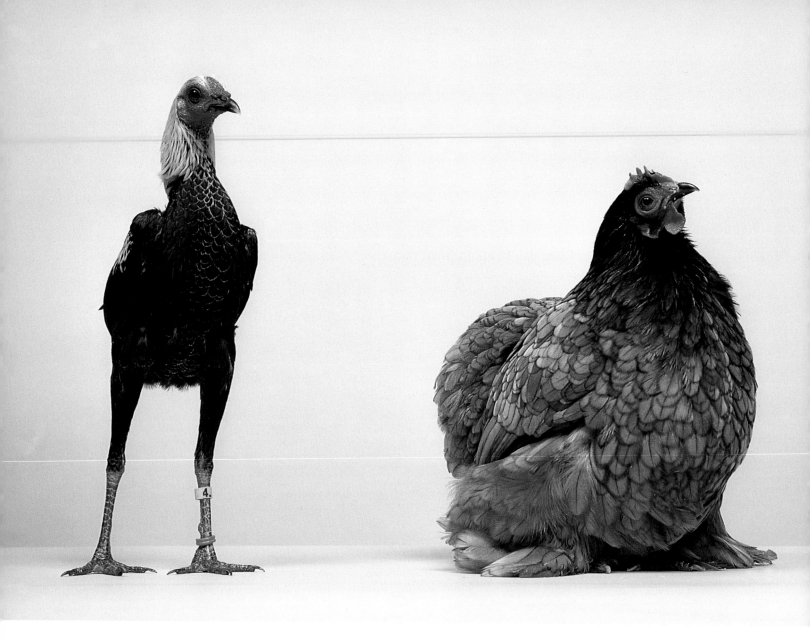

MODERN GAME> BIRCHEN COCKEREL **COCHIN**> BLUE HEN

PREFACE

This is a follow-up to my earlier book *Extraordinary Chickens*, first published in the fall of 2000 and subsequently reprinted a number of times. People who were already aware of the beauty and variety of ornamental chickens were evidently delighted to find a book that displayed these remarkable birds with studio photography. It seems we have also attracted a readership of people who had not previously been aware of show chickens, and who were charmed and intrigued by this introduction to unexpected versions of an otherwise familiar species.

Following the publication of *Extraordinary Chickens*, I did a similar book on pheasants and peacocks, and another on pigeons and doves. During my travels on these and other projects, I occasionally attended poultry shows. At such events, I saw several interesting and attractive chickens that I had not previously photographed. Since a number of good photographs taken for the first book remained unpublished, we decided to choose the best of these and combine them with new photographs of additional breeds, as well as new colors and patterns among the breeds shown in the first book.

When working on my pheasant book, I was able to photograph four species of Jungle Fowl. Although Jungle Fowl look like chickens, they are in fact classified as pheasants and are wild species. The Red Jungle Fowl is the genetic ancestor of all domestic chickens. This had been suspected some time ago by scientists, including Charles Darwin, and modern DNA studies have confirmed it.

I first became aware of the whole subject of exotic chickens when I had an assignment to photograph them for *LIFE Magazine* during the period when it was a monthly publication; as a monthly, the magazine ran more features than it had when it was a more news-oriented weekly. I had done pieces for them on rare dog breeds, on unusual cats, and on show rabbits. When we did ornamental chickens, the magazine printed a large number of photographs, but space limitations forced them to leave aside dozens of wonderful shots. When I later showed a selection of these transparencies to my publisher, it was clear to all of us that with additional photography the world of show chickens had the potential to be an "extraordinary" book subject.

I am following a formula similar to that of the first book with the goal of presenting a photographic celebration of these creatures in all their beauty and variety. It does not set out to be a comprehensive reference work. Breeds that did not fit the adjective "extraordinary" tended to be overlooked in order to leave more space for the most interesting breeds. Also departing from a reference-book style is my frequent use of close-ups rather than limiting myself to profile pictures of entire chickens.

The organization of the book does not always follow the groupings that might be found in a breed-standard reference book. For example, Bantams are normally separated from full-size birds, whether in a book or at a chicken show, but I have sometimes mixed the two sizes. On a page by itself, a picture of a Bantam Cochin looks the same as a picture of a standard Cochin. It is only when the two are placed side

by side in the same picture that the difference is apparent. In reference books, the breeds are often grouped geographically—Asia, the Mediterranean, England, and so on—but this book often mixes place of origin.

I try to photograph these birds as though they are movie stars, with flattering lighting and neutral studio backgrounds. Some of my subjects were more like comedians or character actors than leading men or women; you will also find a few "child actors" here. Recently a breeder complained to me that some of the pictures in my first book were "silly." Well, yes, that's true; some of my subjects stepped onto the stage that way, and camera and film recorded them. I make no apologies, and I explained to the offended breeder that I had stopped short of photographing birds wearing silly outfits. A lady in Ohio had once offered to go home to fetch bonnets, Santa Claus suits, and who knows what else, to dress up her birds. I gently explained that it was "not that sort of book."

A number of people who saw my first book had the same two questions: how did I find so many strange birds, and how did I manage to have them pose for me. The first question is easy to answer— I attended several poultry shows, and even at the small regional events, I could expect to see a wide variety of breeds, and within each breed there would usually be a choice of colors and feather patterns. In the Northern Hemisphere, most shows take place between October and January. In the summer most birds are molting and they don't look their best, while in the spring, breeding and the raising of chicks is the priority. In North America I used *Poultry Press* as a source of information about show schedules, and in Europe I was guided by Hans Schippers.

Persuading the birds to pose for me also turned out to be fairly easy. Most chickens brought to shows are used to being put in unfamiliar situations and to being handled. For the most part, my subjects were very calm and cooperative. Perhaps some were a bit overawed by the experience and instinctively remained patient and passive. Occasionally birds would be on the lookout for a good perch, and from time to time one might flap up to the top of my roll of background paper or try to settle on my lighting equipment. A few just wanted to explore, but there was not normally a tempting destination in sight. These were the exceptions, and in such cases it was usually best to put those birds back in their cages and select another.

I tried to find a quiet corner at a show venue to set up my small poultry portrait studio. When I worked with chickens and other creatures on a *LIFE Magazine* budget, I traveled with a carpenter who would quickly construct an area that gave me some privacy. On more recent shoots for my books, I might find an empty storage room or a deserted office. One big show in Holland was staged in a gymnasium, and I was able to commandeer the men's shower room.

A particular advantage of working at a show is the grooming that takes place. Just as dogs and cats are carefully groomed before and during a competitive show, so are chickens and other birds. They are cleaned, including their faces and feet, and the feathers are made as neat as possible. Sometimes individual feathers are incurably out of alignment and are painlessly plucked. I learned to appreciate the value of grooming when I tried to take some pictures at a breeder's barn. I had been there to photograph very young chicks, and when I had finished, I decided to shoot some of the adult birds. Although I was the guest of a successful breeder with many fine chickens, my pictures showed flaws that would have been corrected if the birds had been groomed for display.

PHOENIX > SILVER **DRENTE FOWL** > RUMPLESS YELLOW PARTRIDGE PULLET

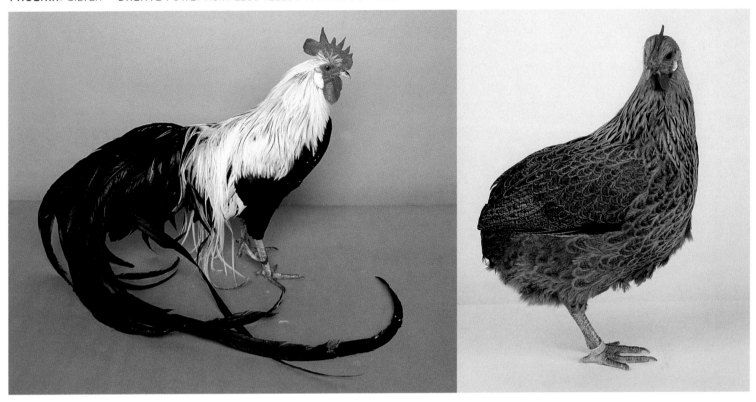

ARAUCANA > GOLDEN DUCKWING **YOKOHAMA** > RED-SHOULDER COCKEREL

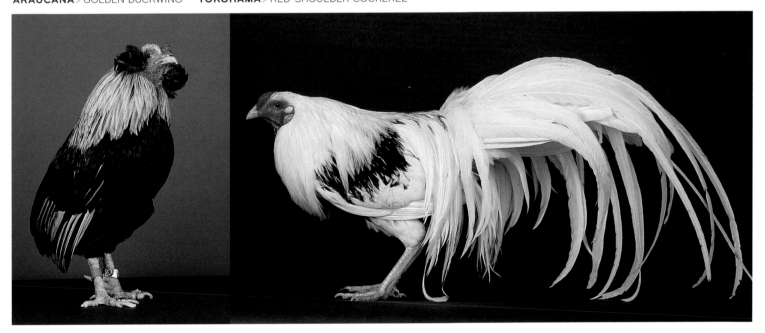

In North America I was not always able to photograph my first-choice specimens at a show because I was not always able to find the owner to obtain his or her permission. Naturally breeders would want to study and enjoy all the other birds and could not be expected to hover around their own entries all day. So I apologize to experts who might have preferred to see their favorite breeds better represented. In Europe I found this problem did not exist, at least in Germany and the Netherlands. There, it was usually sufficient to have a blanket permission from show organizers. I would then be allowed to place a notice in the cage of a selected bird, indicating that the inmate had been temporarily removed for photog-

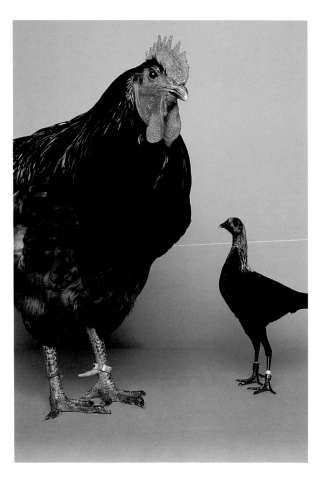

raphy. Several well-illustrated bird publications devoted to exhibition poultry exist in those countries, and cooperation with professional photographers is accepted as being normal as well as being good public relations for the hobby.

On one recent occasion I came across an American breeder who was perhaps in a bad mood at the time and who wondered why he should cooperate with my work. He assumed that I would be enjoying some income from my photographs, whereas he would not. I had of course already considered this notion and could give him an answer. Most of the owners of good-looking fowl liked the idea that their favorite birds could be displayed in a flattering way with glamorous photographs; they were confident that the book would be well designed and beautifully printed. Perhaps some of them had been confronted by the skepticism of friends and family about the merits of caring for "mere chickens," and perhaps they were looking forward to being able to show people a book that explained their chicken enthusiasm. And of course many owners were flattered that their own bird or birds had been chosen as worthy representatives of a particular breed. This would be a good moment to thank them and to apologize to people whose chickens were photographed but eventually excluded from the final layouts for various reasons not connected with the quality of the specimens.

For the most part, I found myself photographing mainly roosters, and rather than endlessly repeat this in my captions, I have only identified the birds that are hens, pullets (young females), or cockerels (young males). These distinctions are similar to those in horses between stallions and colts, mares and fillies. Roosters and cockerels tend to have more attractive plumage, and when their pheasant ancestry is considered, it is easy to understand why this is so. Wild pheasants nest on the ground and naturally the hens are safer sitting on eggs or tending chicks when their coloring is like a camouflage, making them less conspicuous to predators. Males, on the other hand, are dressed in feathers that make them appear glamorous to potential mates, and at the same time make them attractive, even extraordinary, subjects for the camera. I hope you agree as you turn the pages.

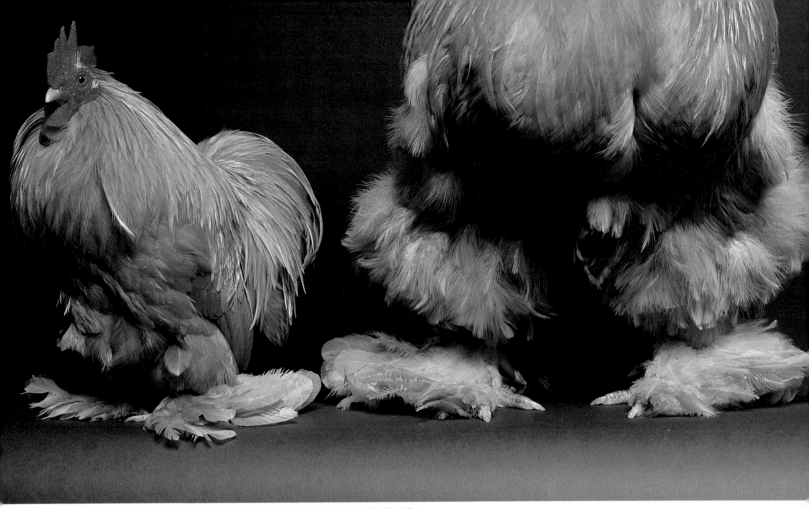

opposite: **JERSEY GIANT**> BLUE **MODERN GAME**> BANTAM BIRCHEN HEN

above: **COCHIN**> BANTAM AND STANDARD, BUFF below: **BRAHMA**> STANDARD AND BANTAM, LIGHT

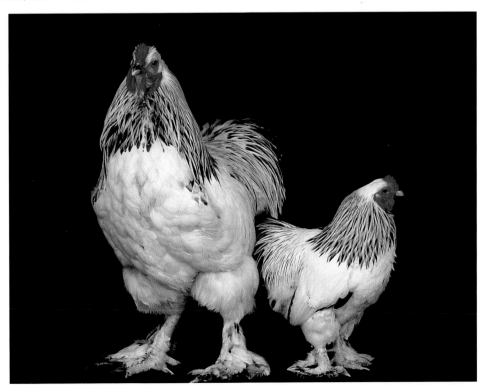

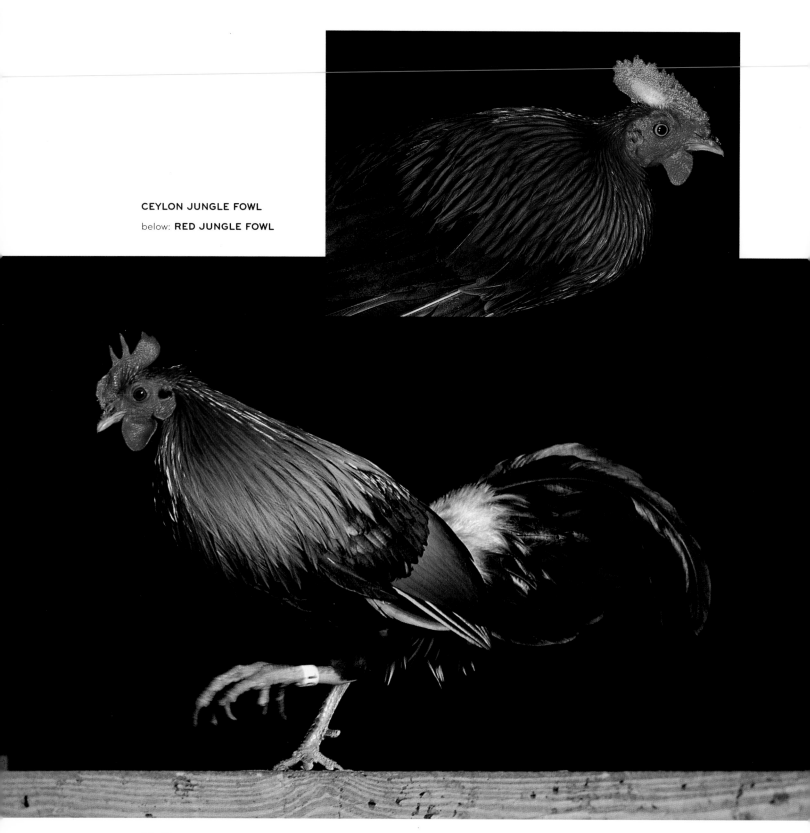

CEYLON JUNGLE FOWL
below: **RED JUNGLE FOWL**

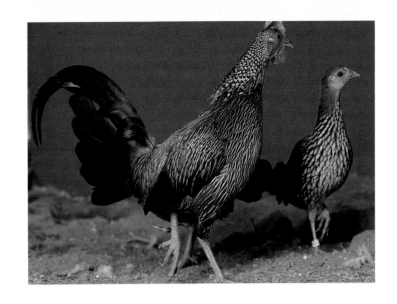

GREY JUNGLE FOWL > COCK AND HEN
below: **GREEN JUNGLE FOWL**

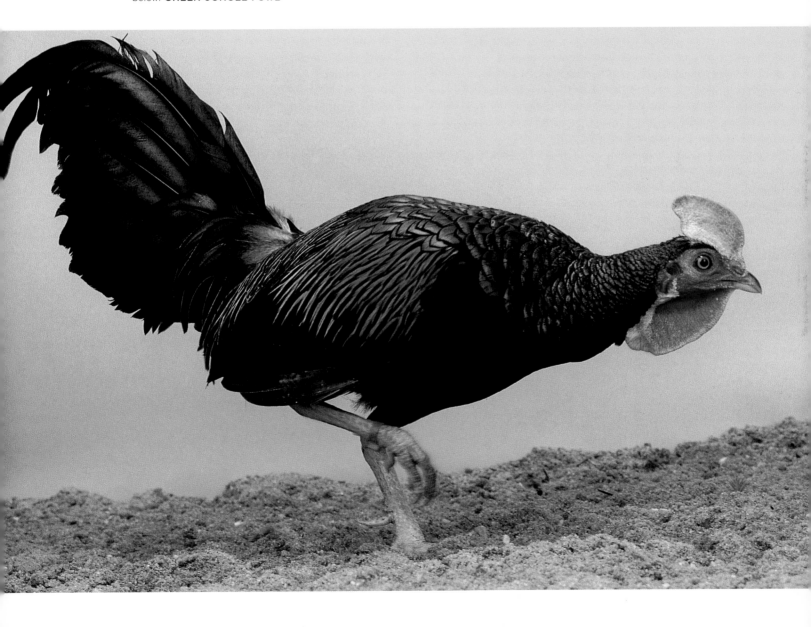

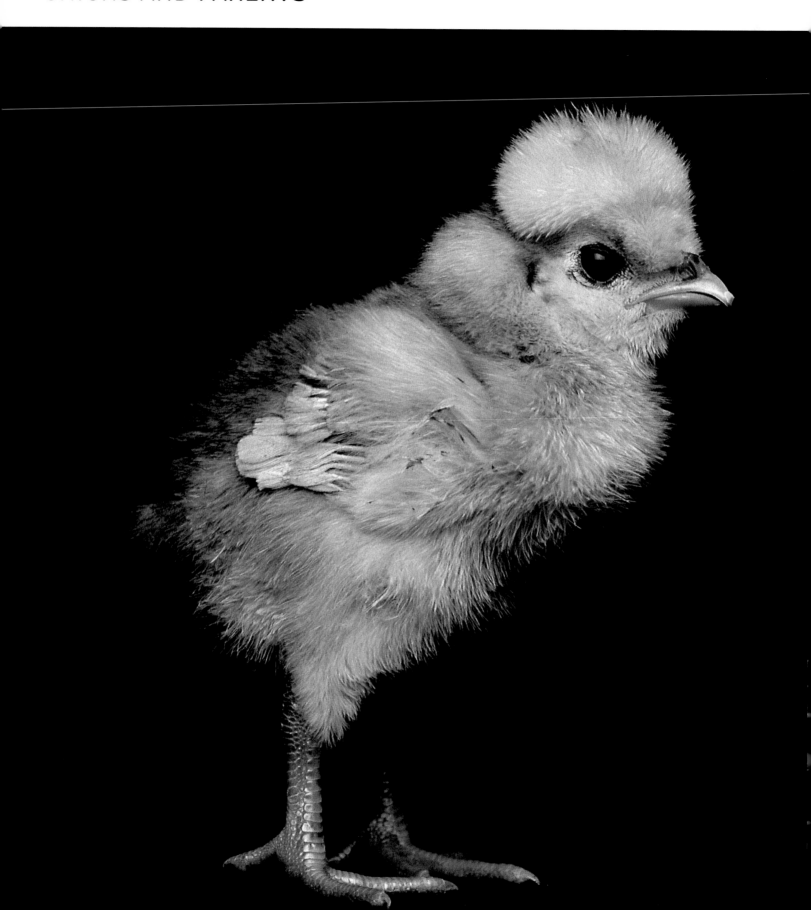

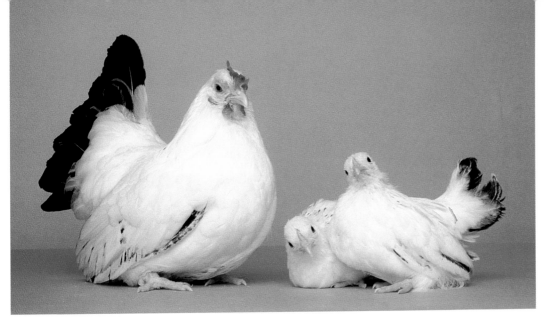

opposite:
POLISH> WHITE-CRESTED
BLUE CHICK

JAPANESE> BLACK-TAILED
WHITE HEN AND CHICKS

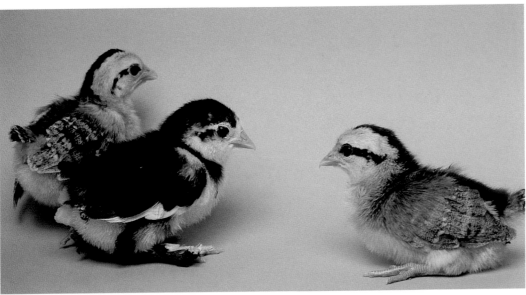

MIXED BANTAM CHICKS

CUBALAYA> BLACK-BREASTED
RED CHICKS

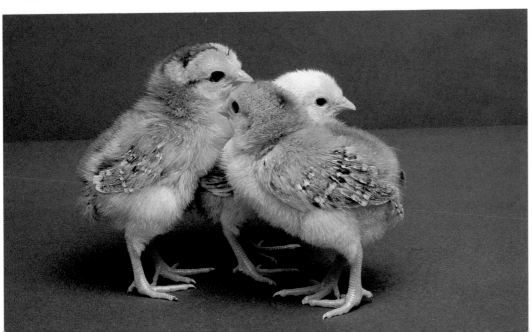

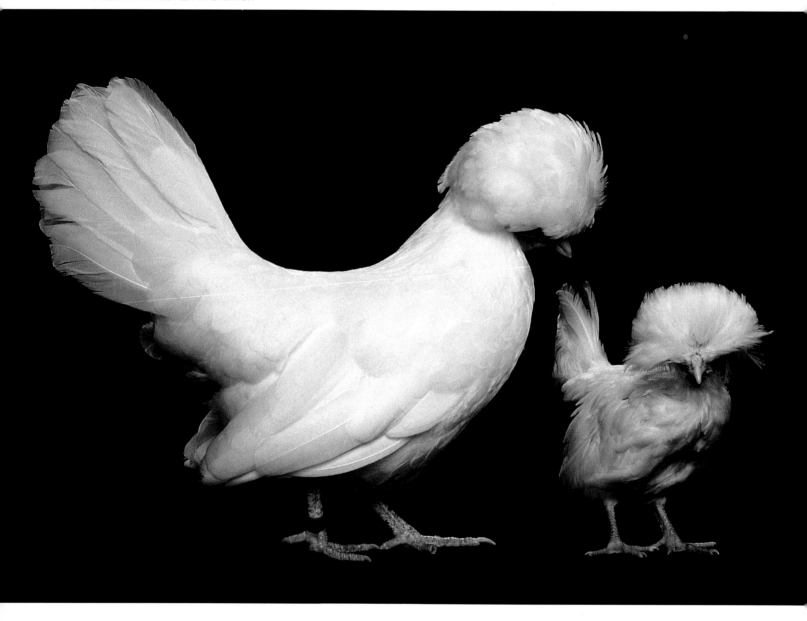

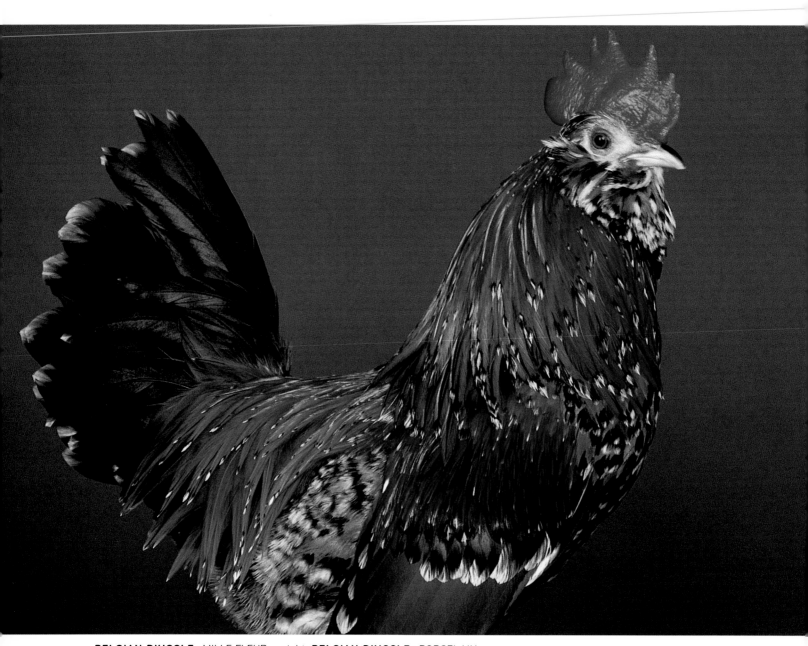

BELGIAN D'UCCLE > MILLE FLEUR right: **BELGIAN D'UCCLE** > PORCELAIN

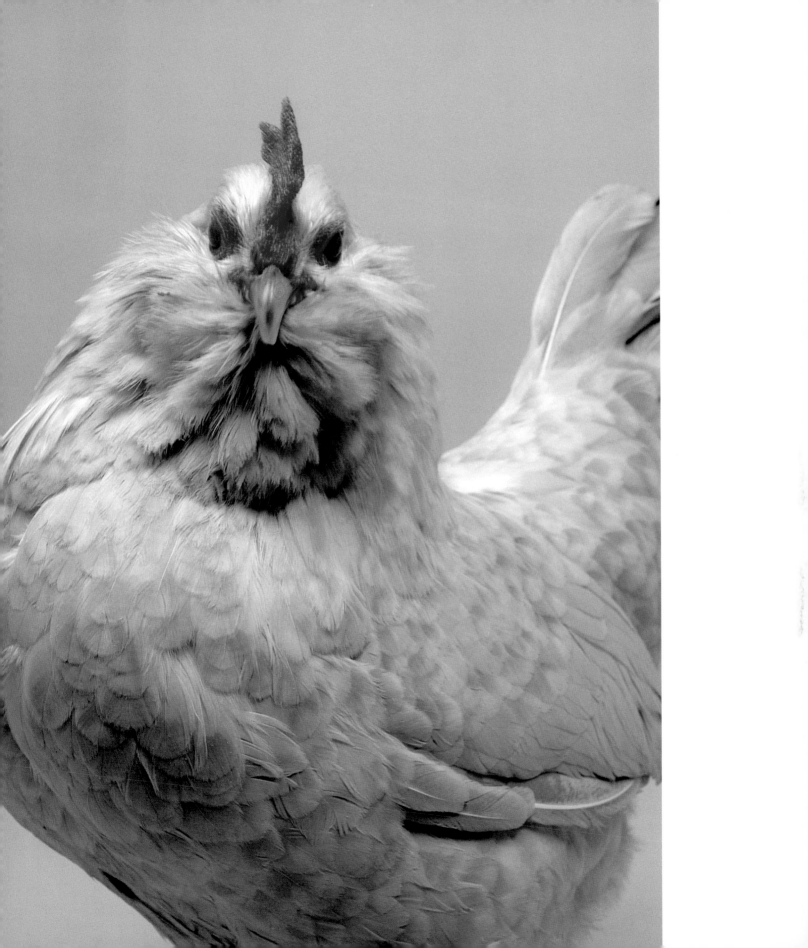

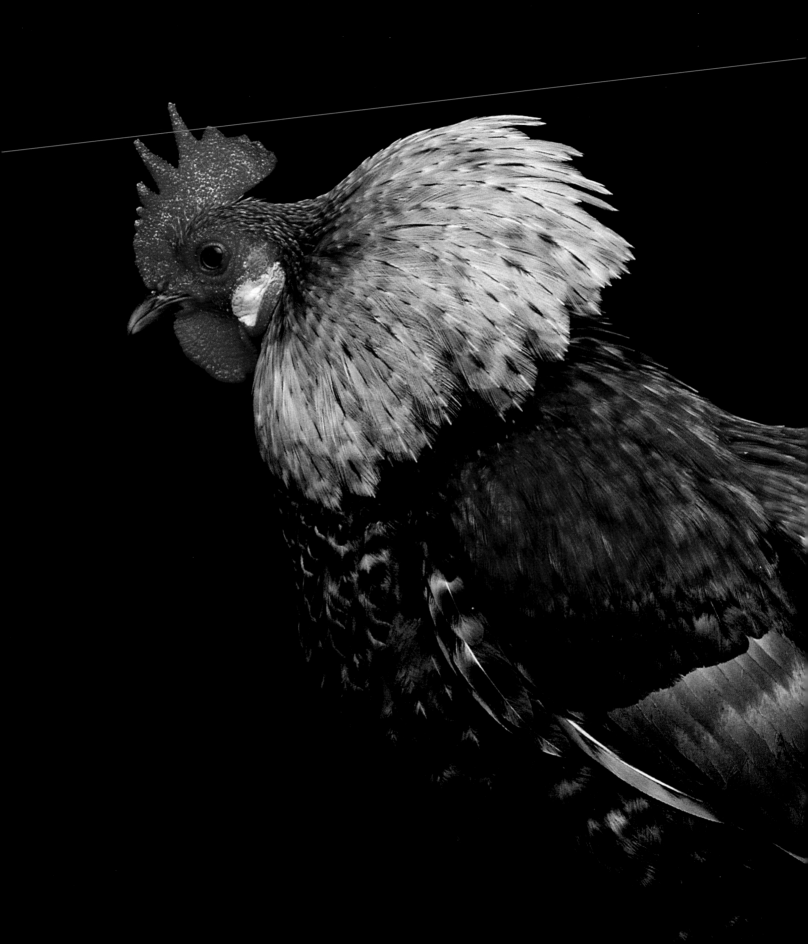

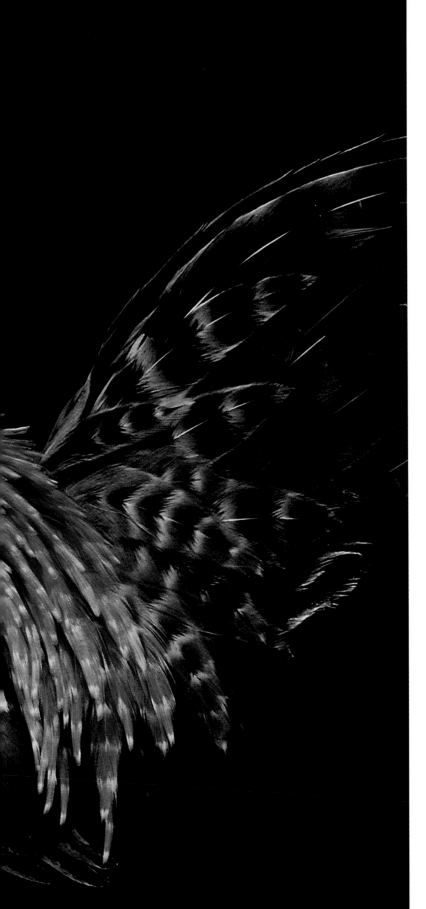

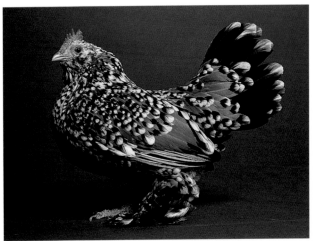

BELGIAN D'UCCLE > MILLE FLEUR HEN

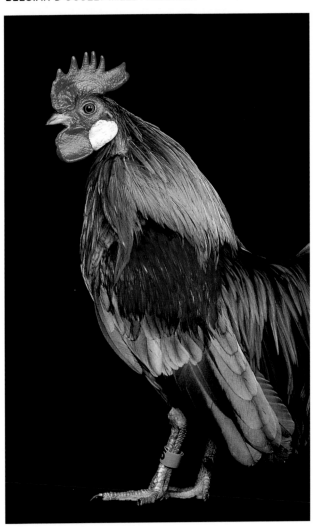

DUTCH > BLUE LIGHT BROWN COCKEREL
opposite: **DUTCH** > CRELE

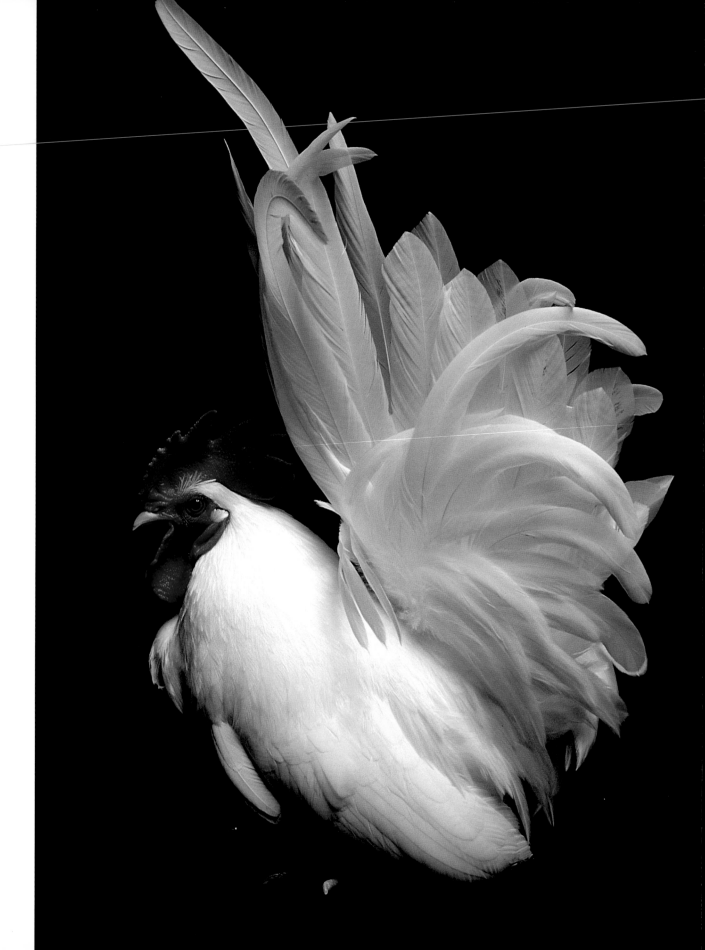

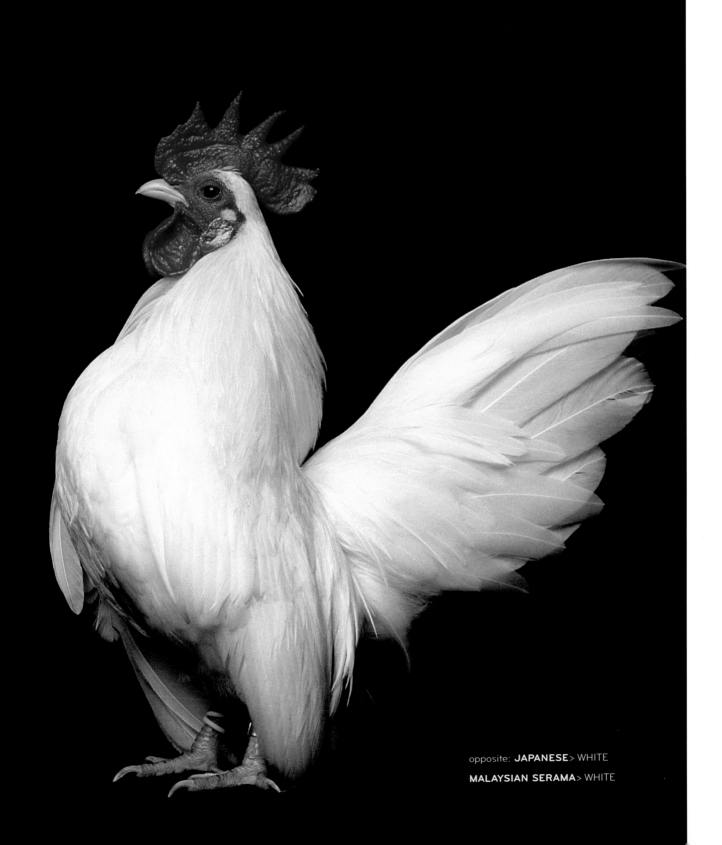

opposite: **JAPANESE**> WHITE

MALAYSIAN SERAMA> WHITE

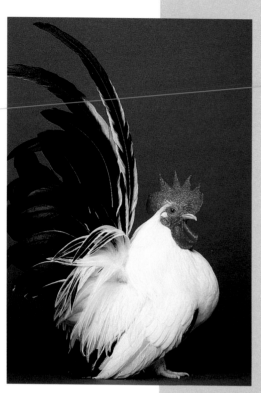

JAPANESE>
BLACK-TAILED WHITE
COCKEREL

JAPANESE> GRAY

opposite:
JAPANESE> BLACK-TAILED
BUFF

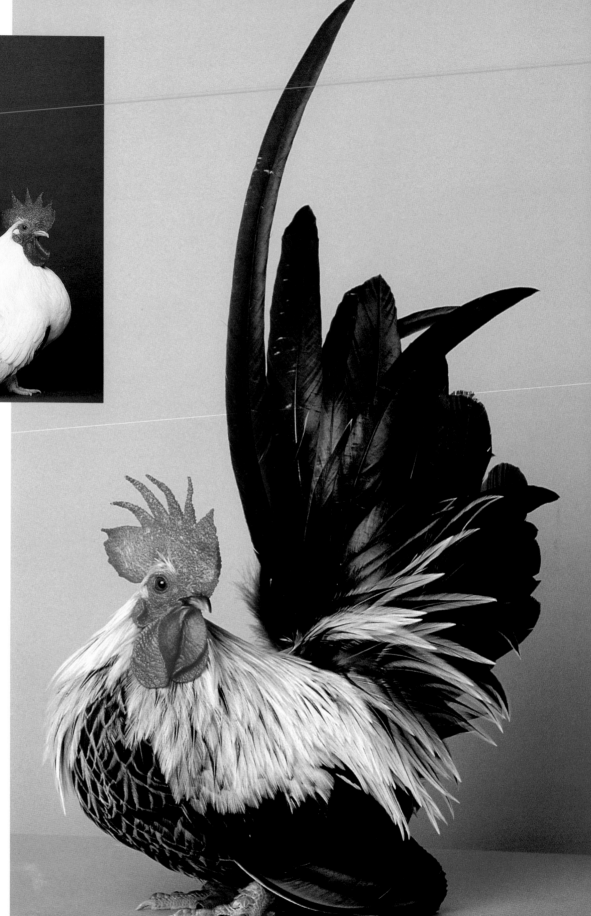

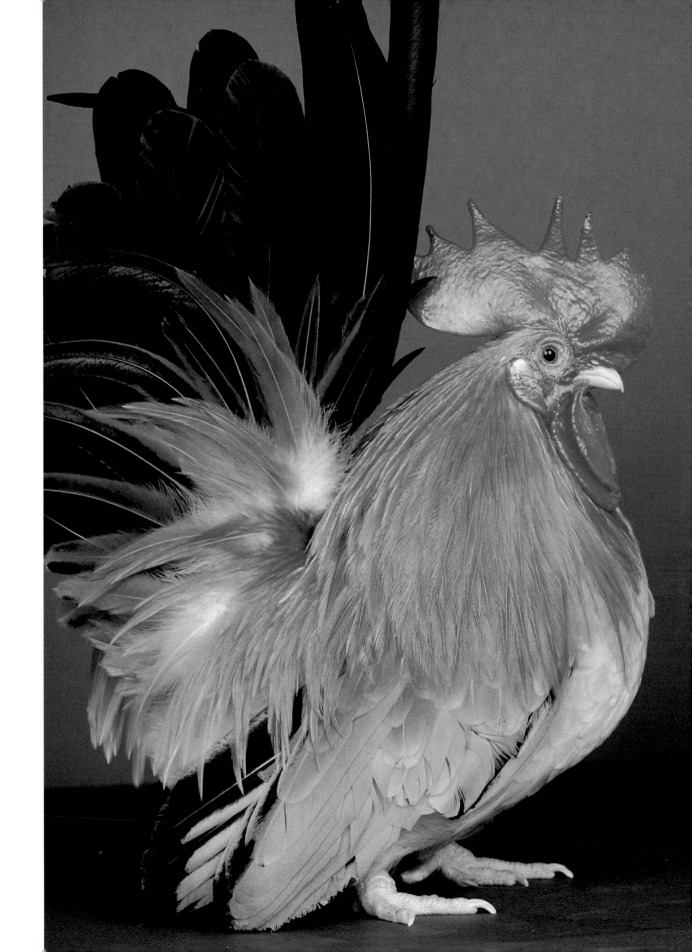

MODERN GAME>
BIRCHEN COCKEREL

MODERN GAME>
BROWN-RED PULLET

MODERN GAME>
BLACK-BREASTED RED
COCKEREL

below: **MODERN GAME**>
LEMON-BLUE COCKEREL

opposite: **MODERN GAME**>
RED PYLE

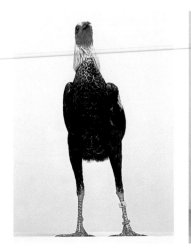
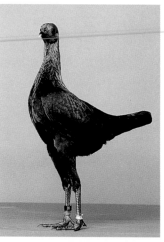
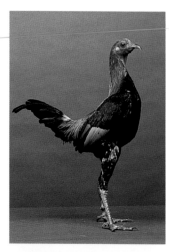

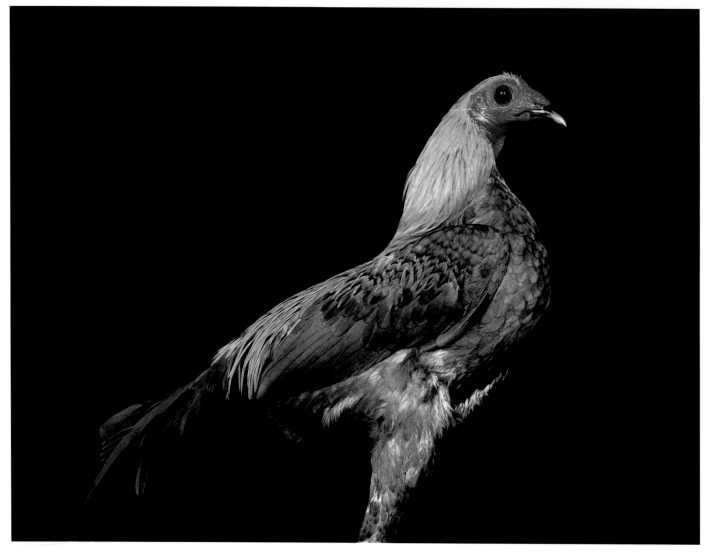

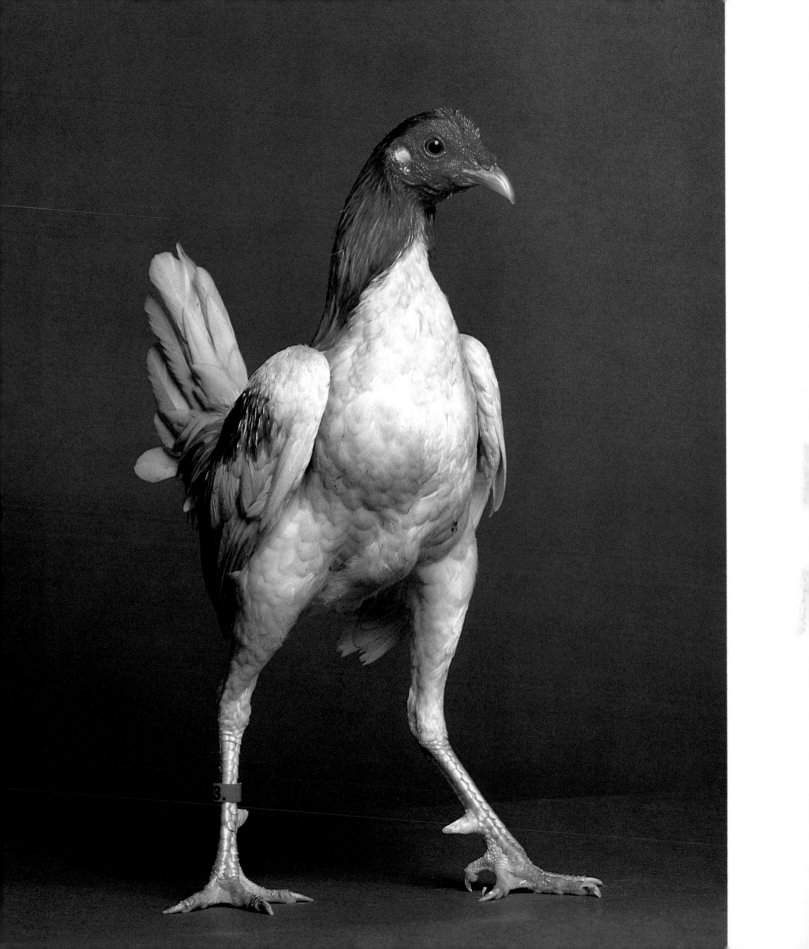

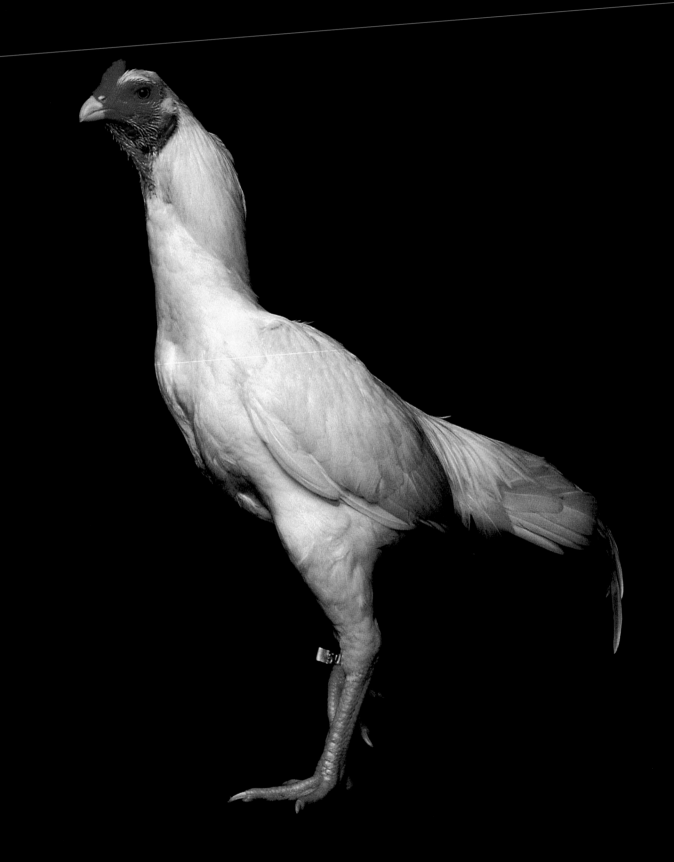

opposite: **ASIL** > WHITE COCKEREL

CORNISH > DARK HEN **MODERN GAME** > BIRCHEN

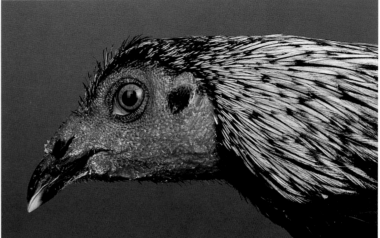

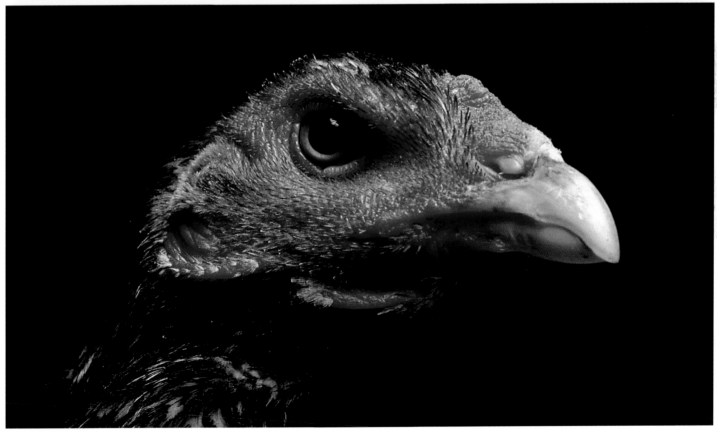

SHAMO > DARK

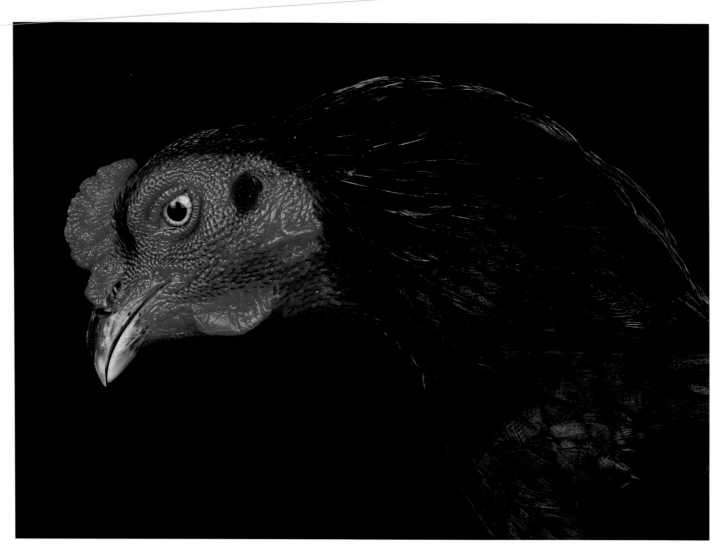

ASIL > BLACK

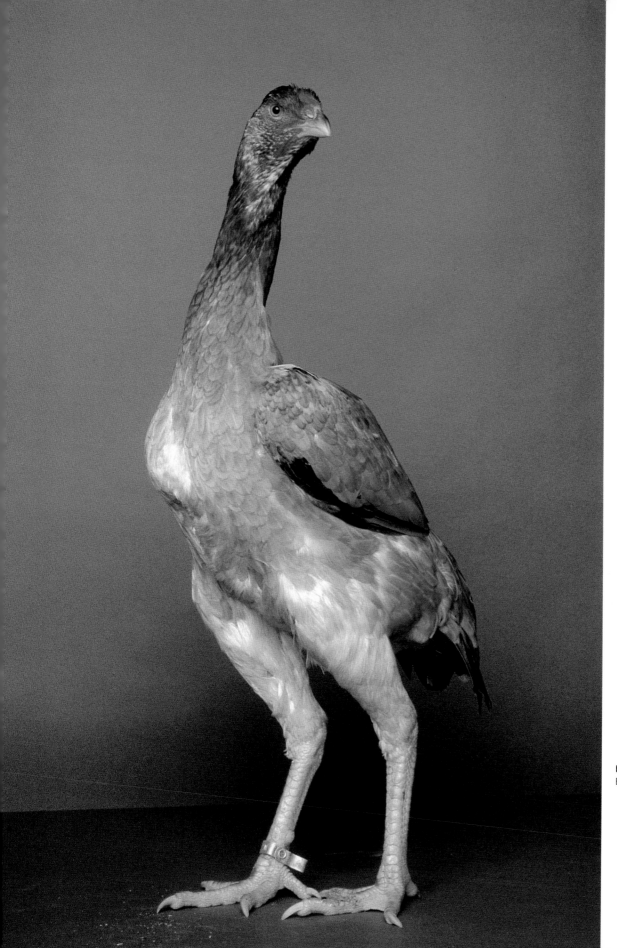

MALAY >
BLACK-BREASTED RED PULLET

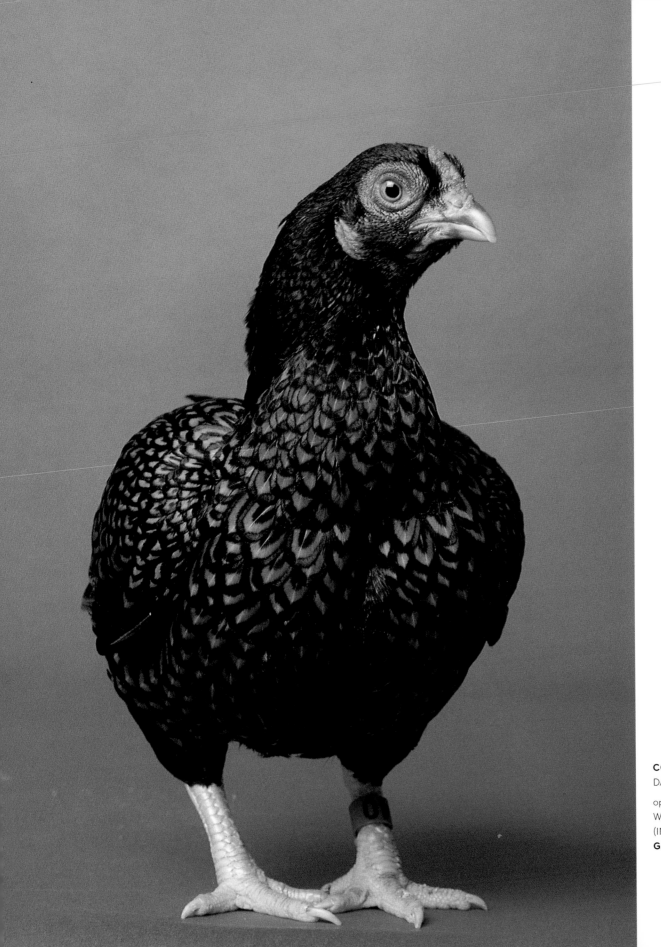

CORNISH>
DARK HEN

opposite: **CORNISH**>
WHITE-LACED RED
(IN BRITAIN: **INDIAN**
GAME> JUBILEE)

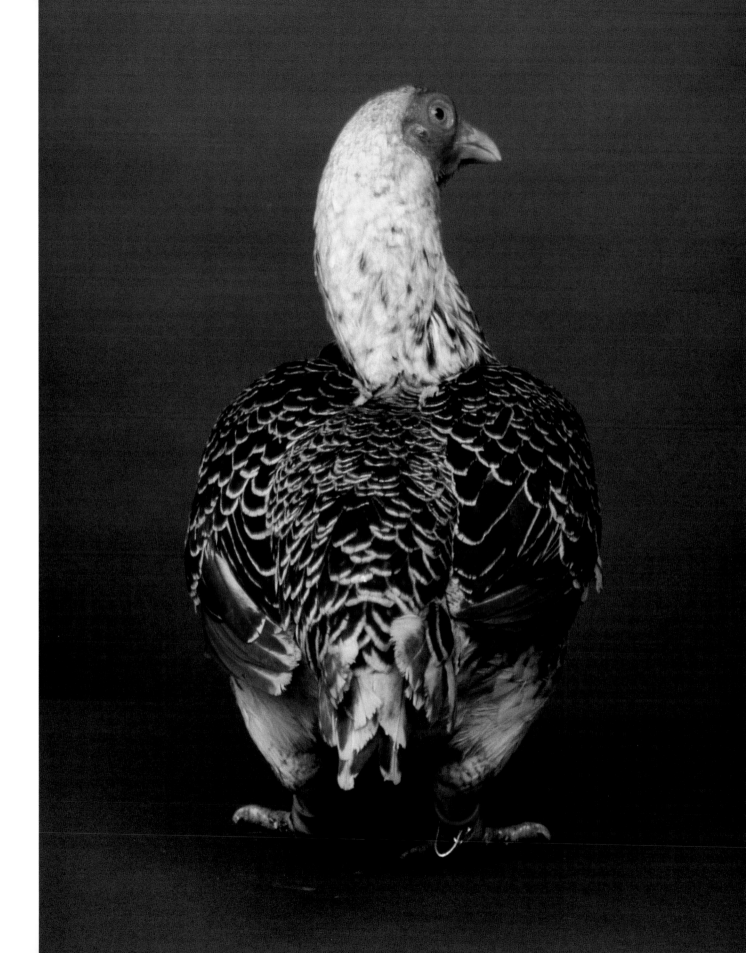

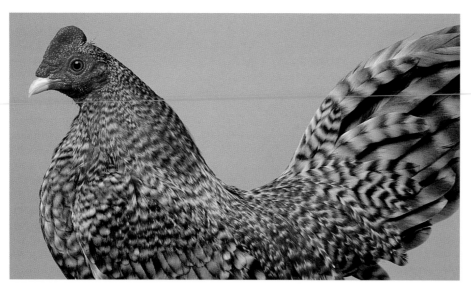

OLD ENGLISH GAME> CRELE HEN

below: **OLD ENGLISH GAME**>
WHEATEN PULLET

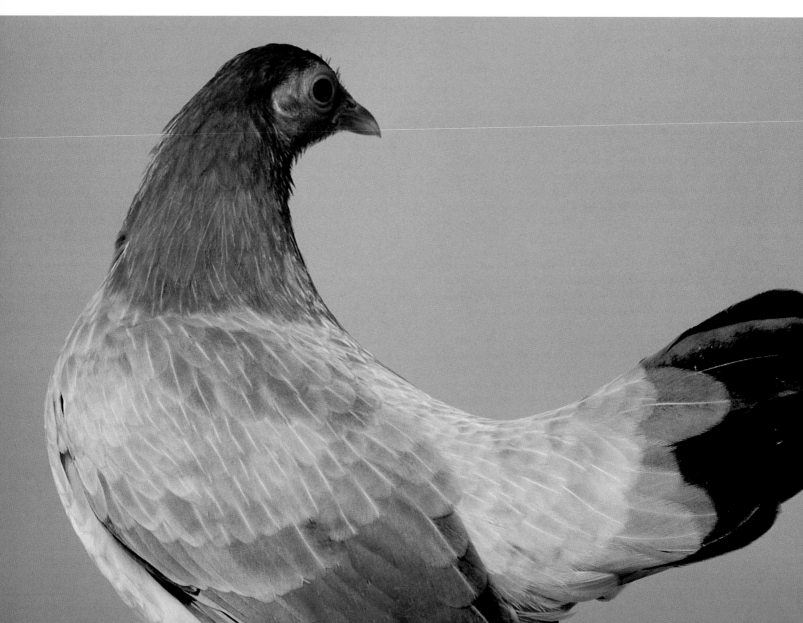

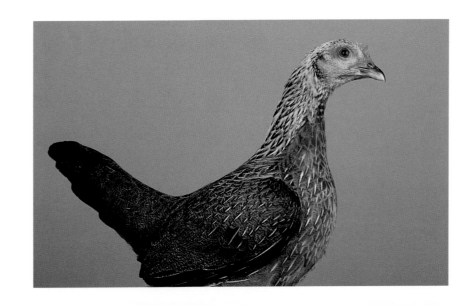

OLD ENGLISH GAME > SILVER-DUCKWING
PULLET

below: **OLD ENGLISH GAME** >
BLUE-BREASTED RED PULLET

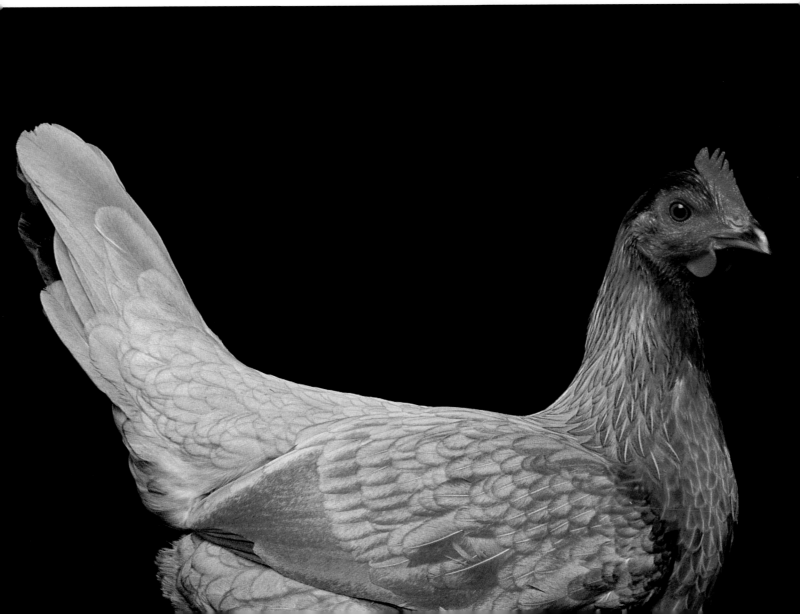

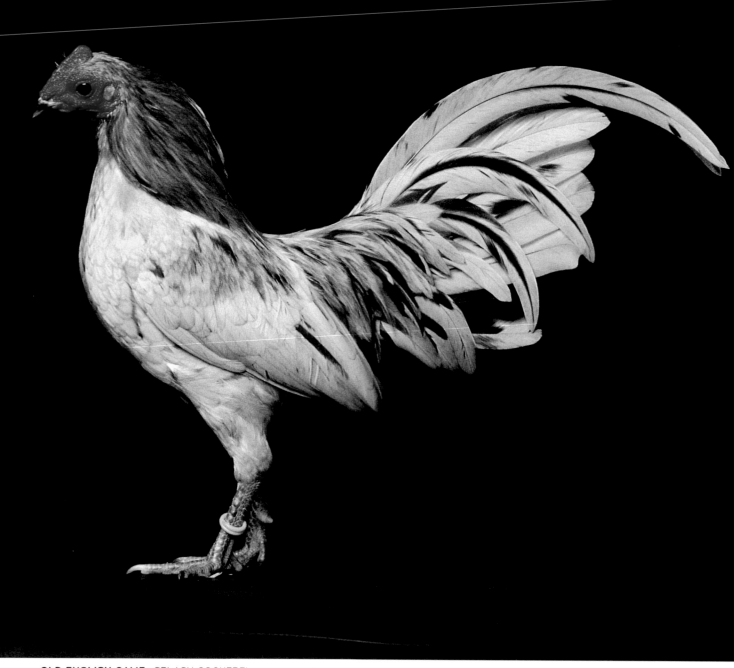

OLD ENGLISH GAME> SPLASH COCKEREL

opposite:
(top) **OLD ENGLISH GAME**> SILVER-QUILL PULLET
(below) **OLD ENGLISH GAME**> MILLE FLEUR PULLET

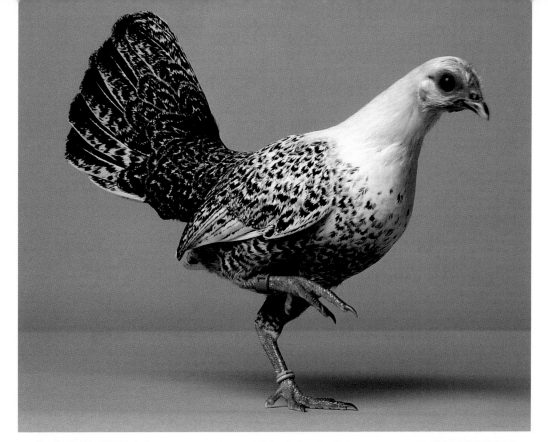

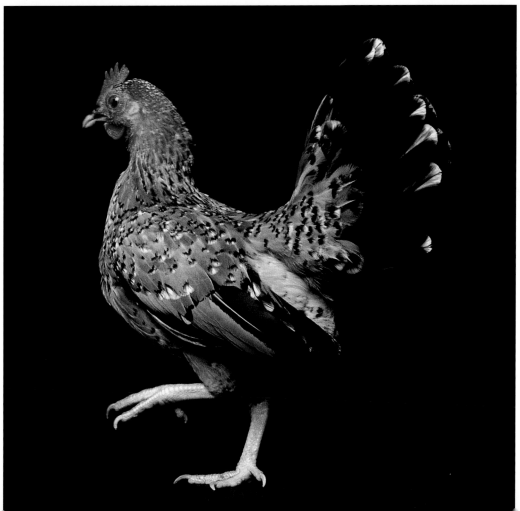

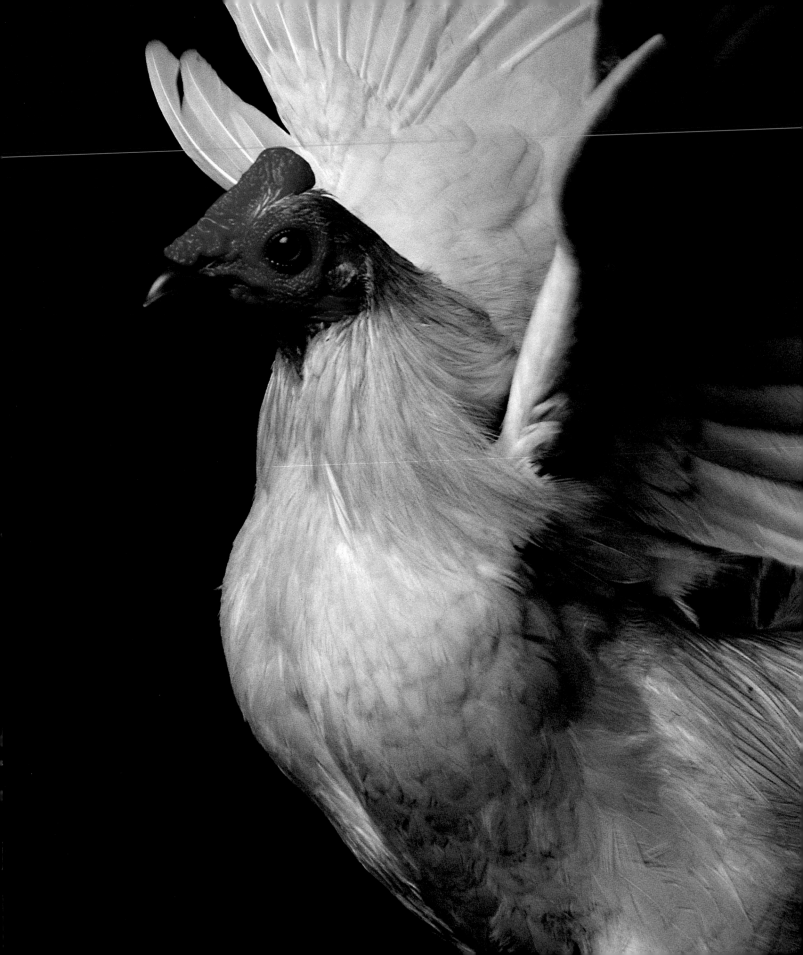

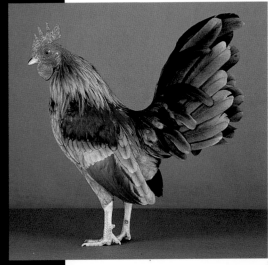

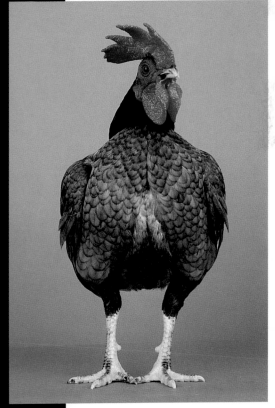

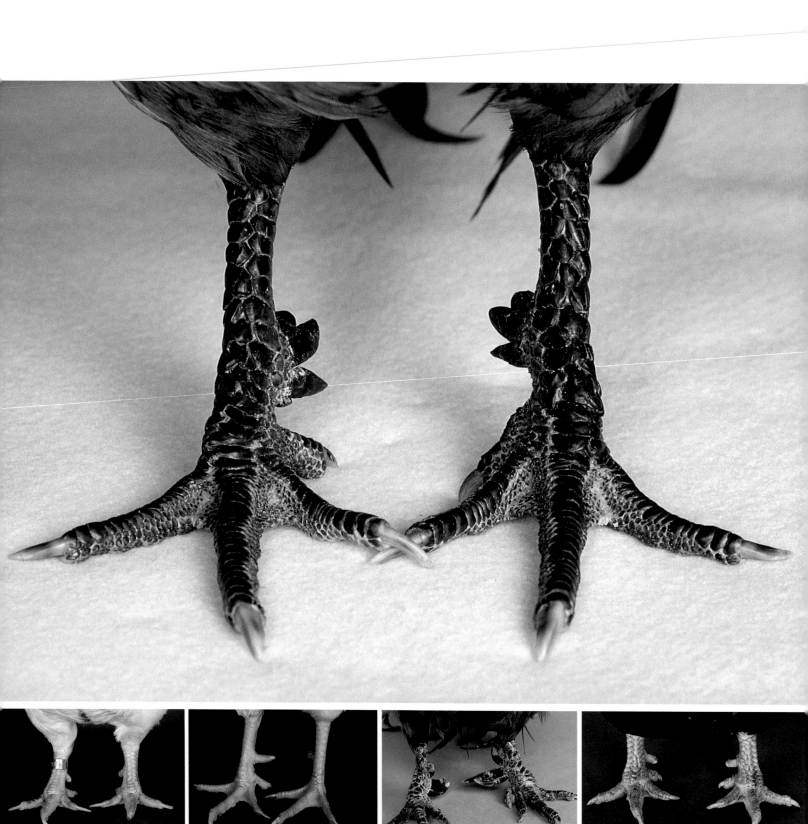

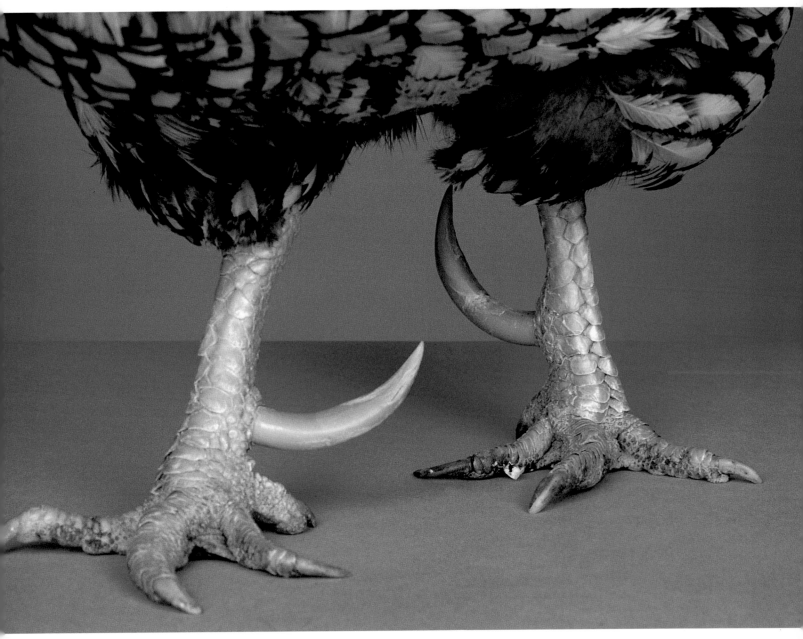

opposite: (top) **SUMATRA**> BLUE

CORNISH> WHITE **PLYMOUTH ROCK**> WHITE **SUMATRA**> BLACK **CORNISH**> DARK

above: **WYANDOTTE**> SILVER LACED

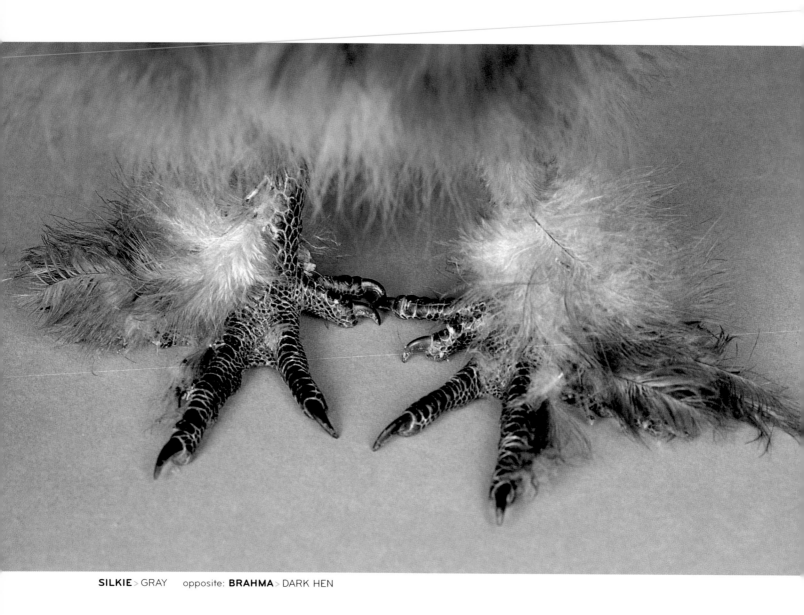

SILKIE > GRAY opposite: **BRAHMA** > DARK HEN

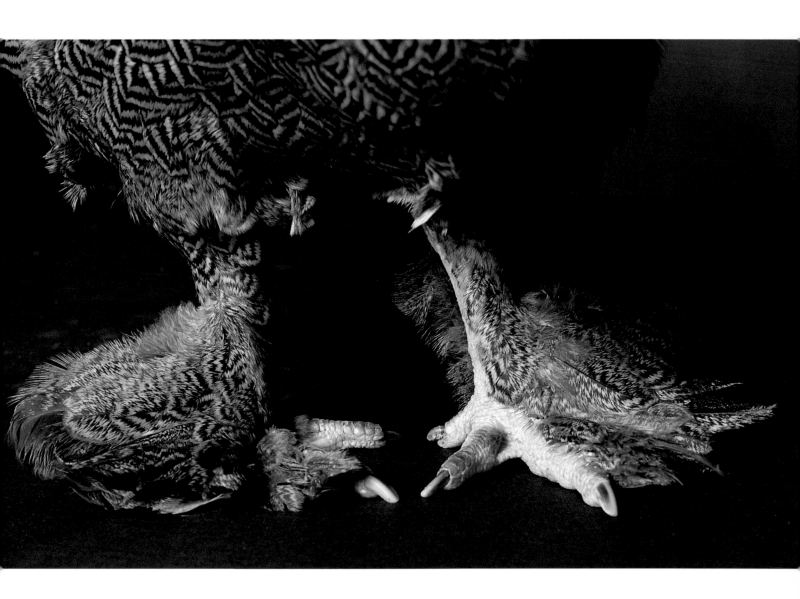

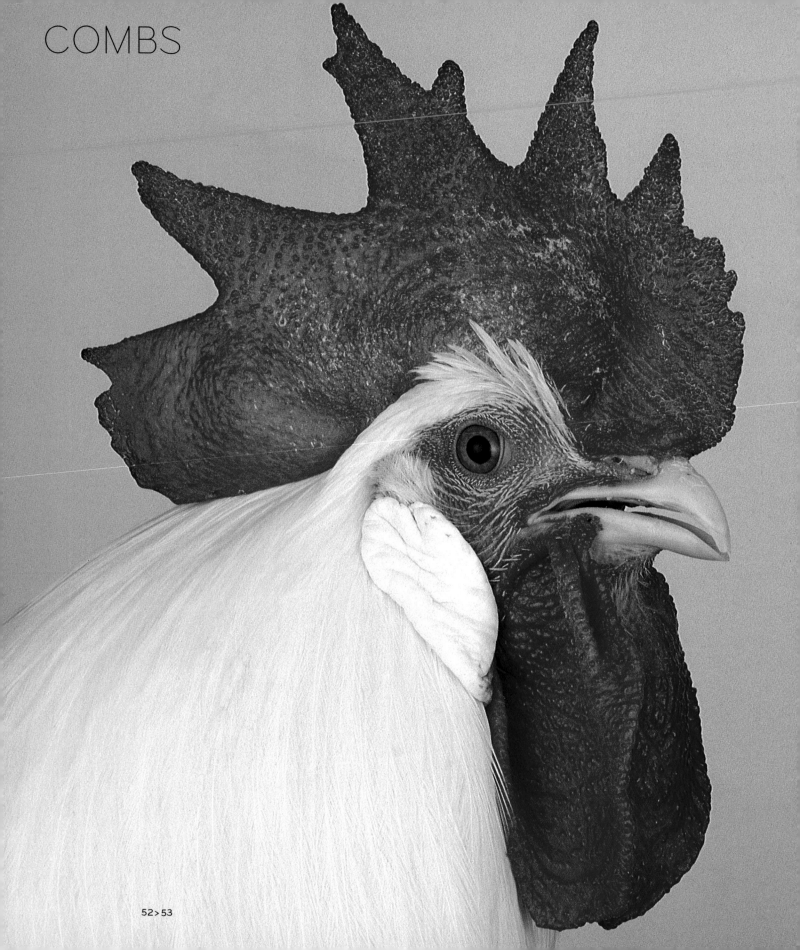

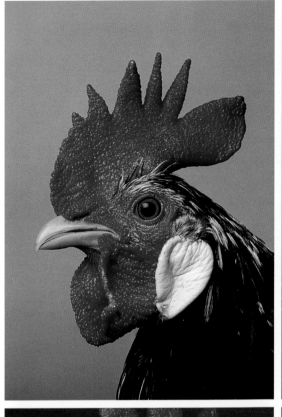
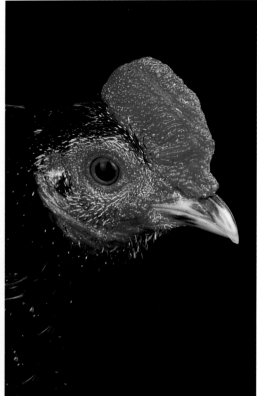

opposite: **MINORCA**> WHITE

clockwise from top left:
ANCONA> COCKEREL

OLD ENGLISH GAME>
SPANGLED

ROSECOMB> BLACK

SPANISH WHITE FACE

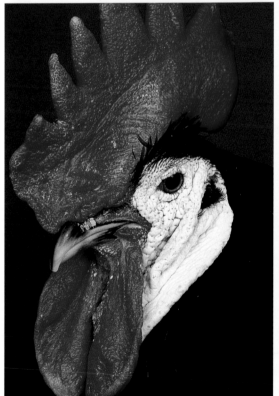
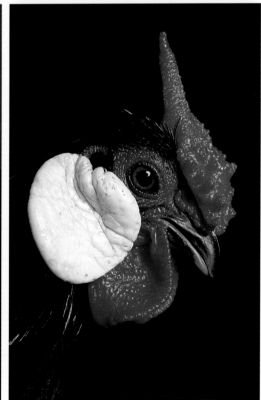

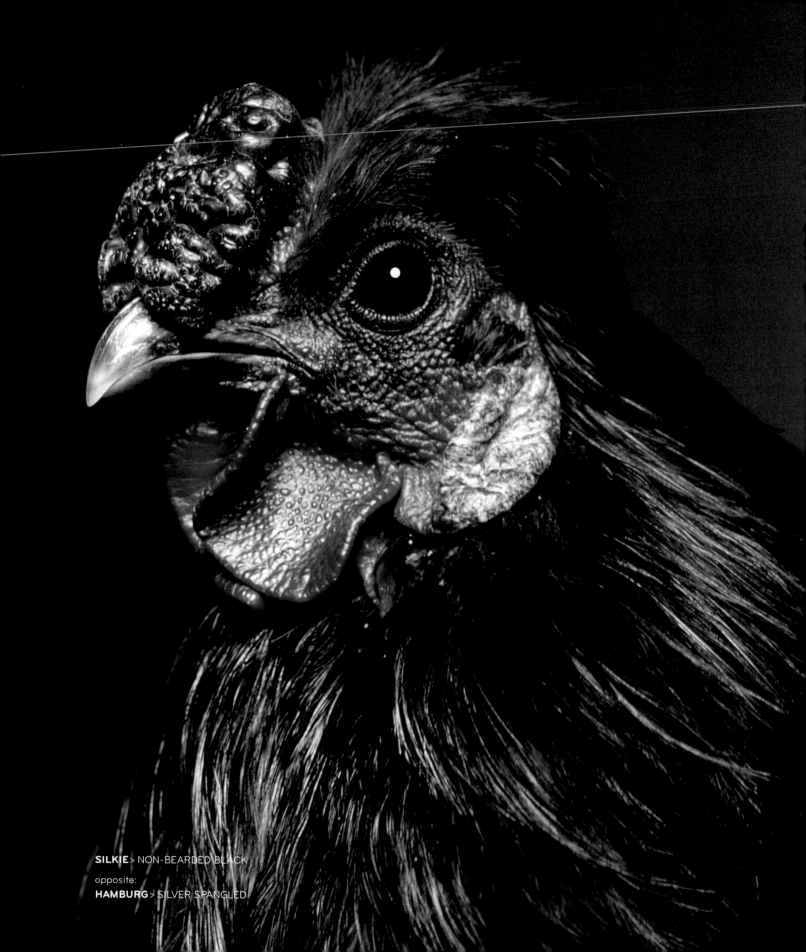

SILKIE > NON-BEARDED BLACK

opposite:
HAMBURG > SILVER SPANGLED

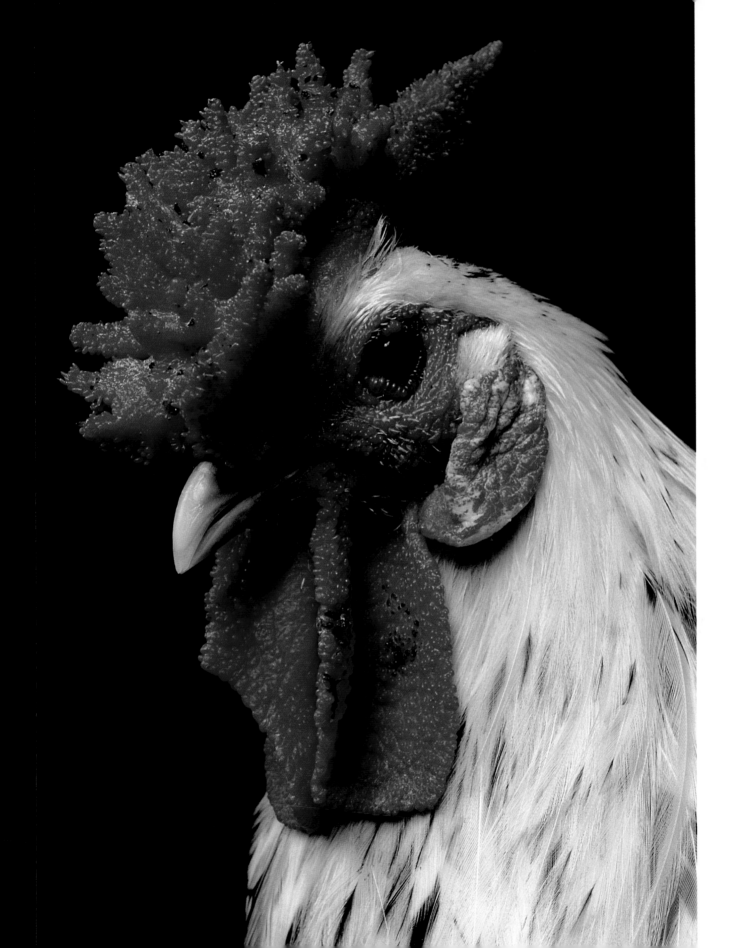

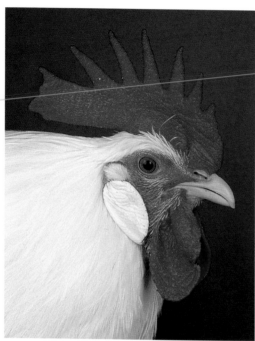

clockwise from left:
LEGHORN> WHITE COCKEREL

SICILIAN BUTTERCUP

AUSTRALORP> BLACK COCKEREL

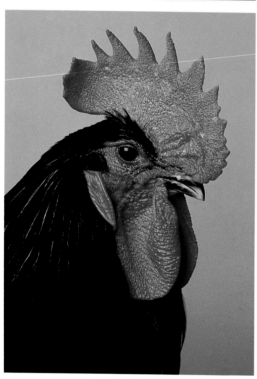

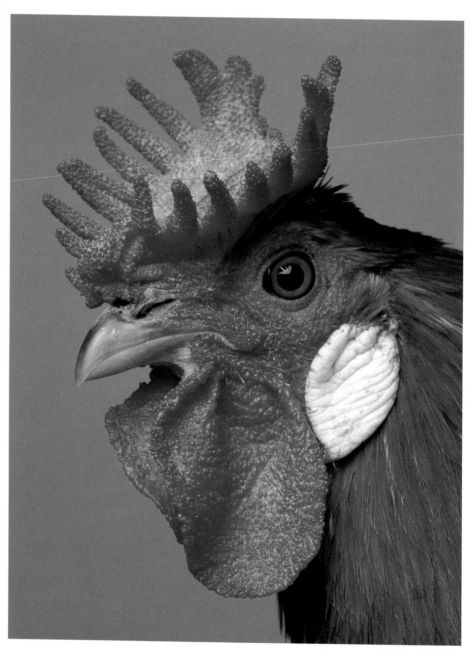

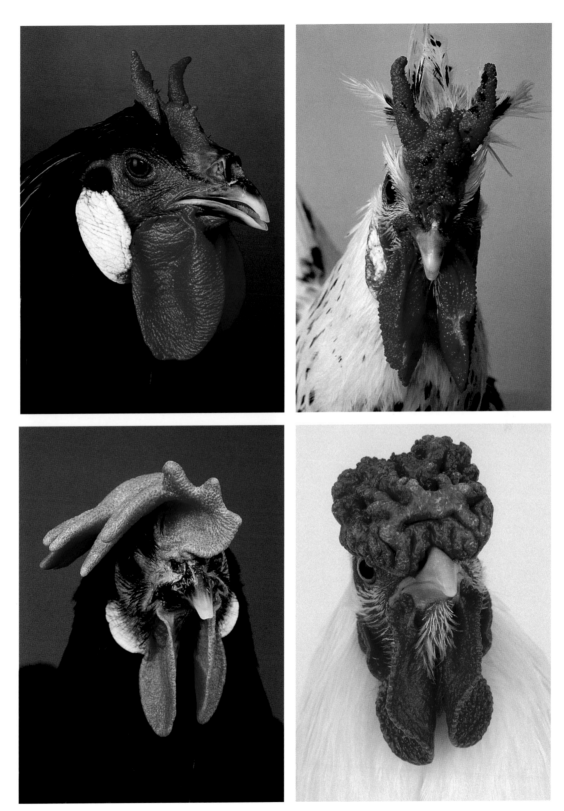

top row: **LA FLÈCHE**> BLACK **APPENZELLER SPITZHAUBEN**> SILVER SPANGLED

bottom row: **MINORCA**> BLACK HEN **WYANDOTTE**> WHITE COCKEREL

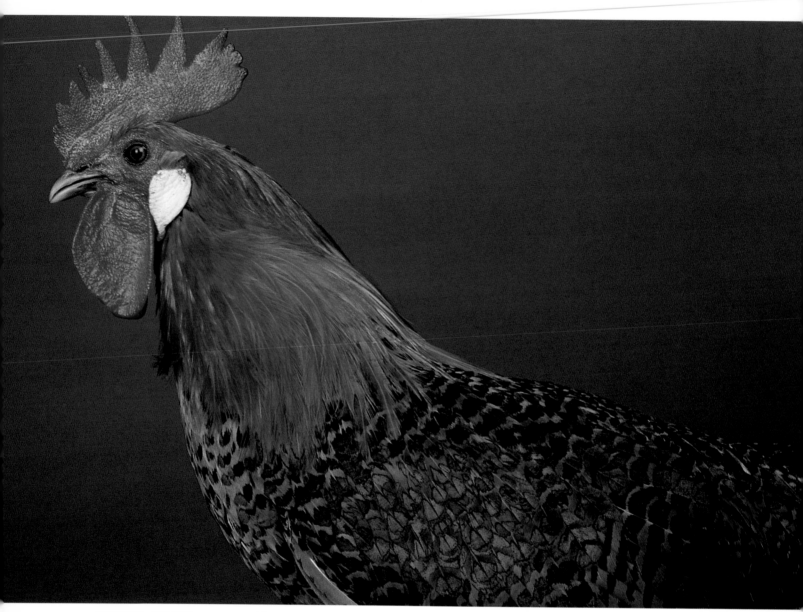

CAMPINE > GOLDEN opposite: **SCOTS GREY**

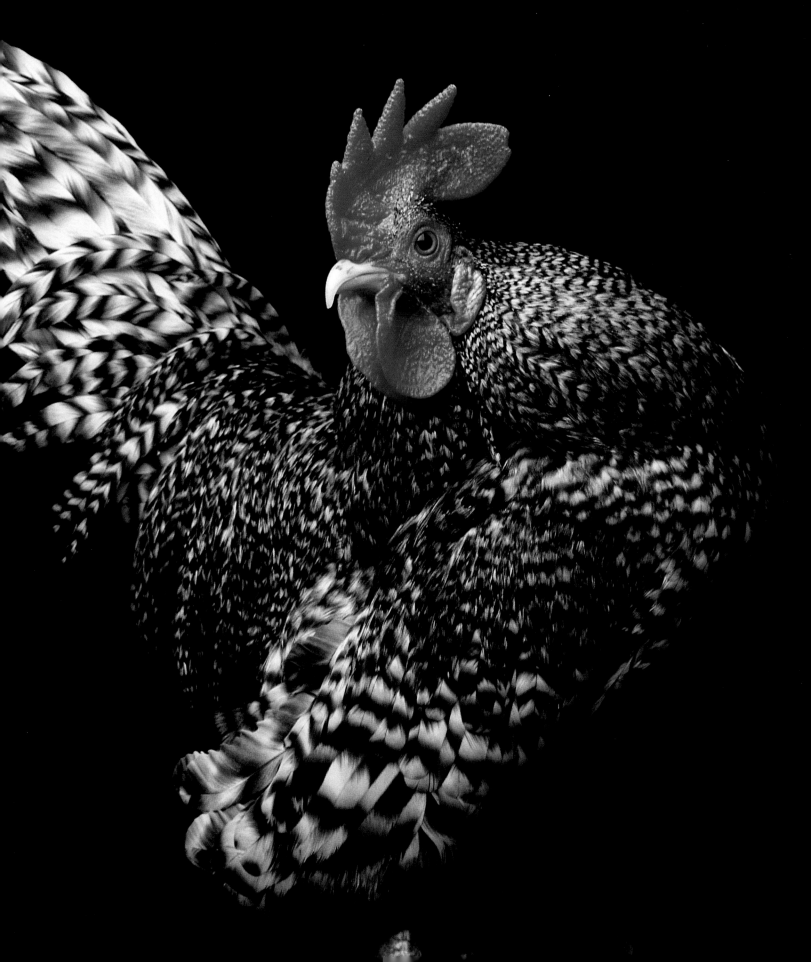

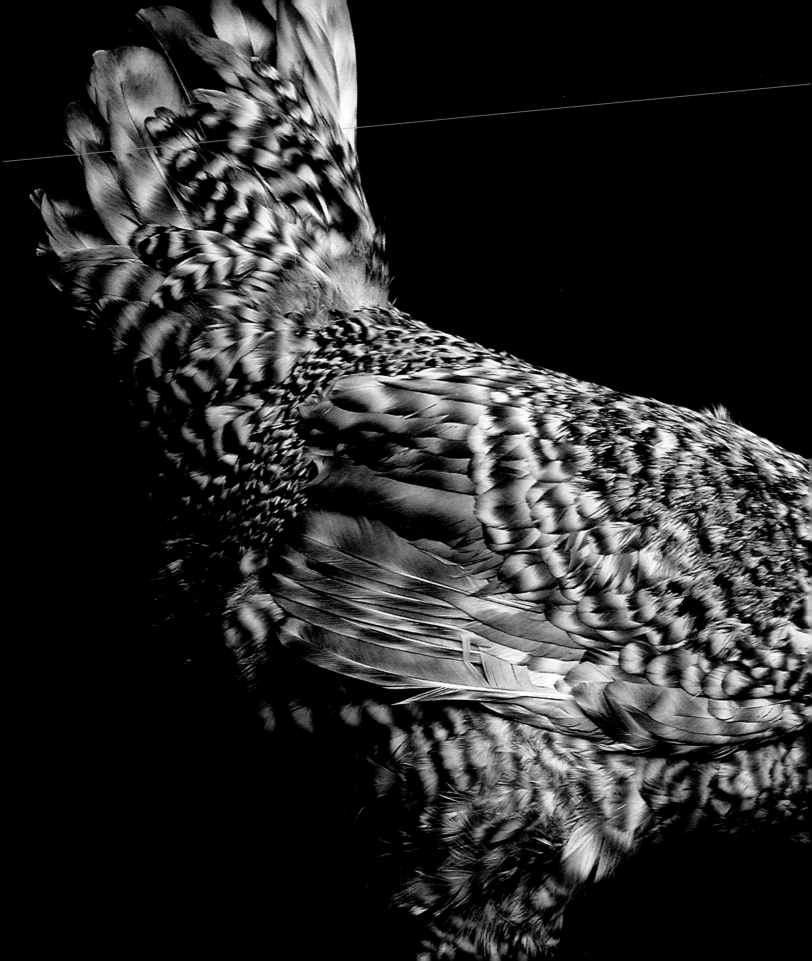

above: **CAMPINE**> SILVER

left: **MARANS**

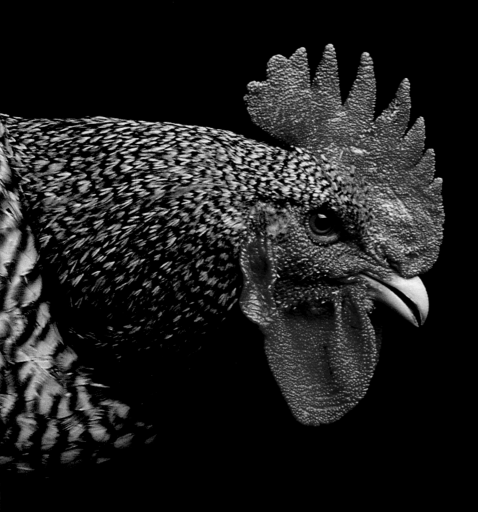

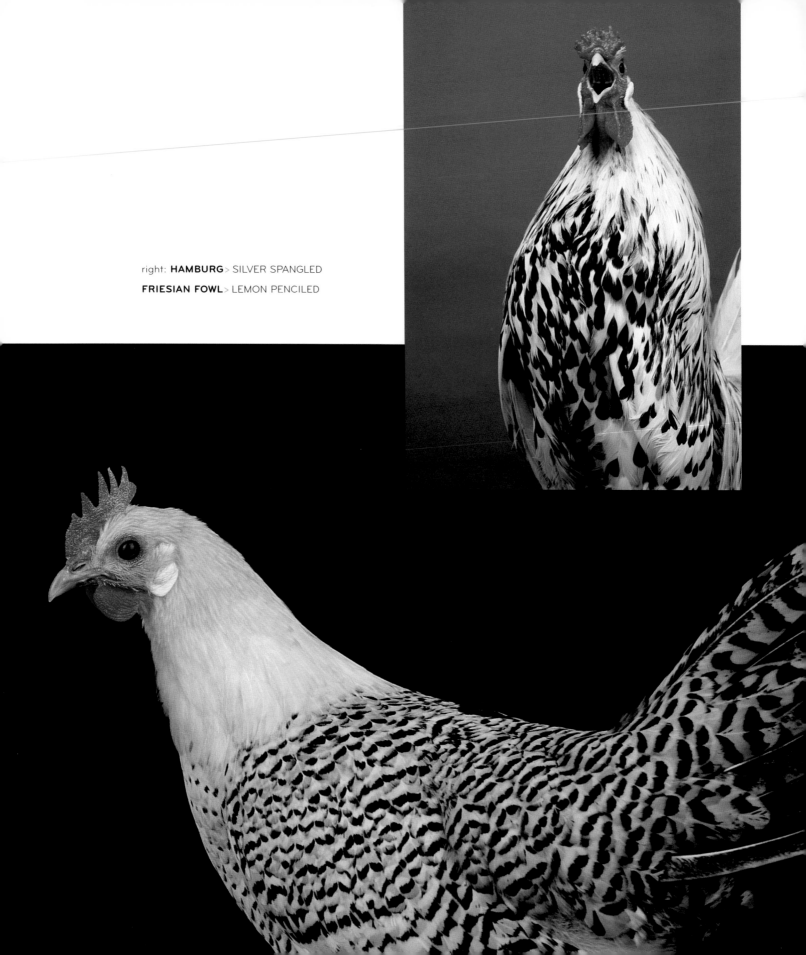

right: **HAMBURG** > SILVER SPANGLED

FRIESIAN FOWL > LEMON PENCILED

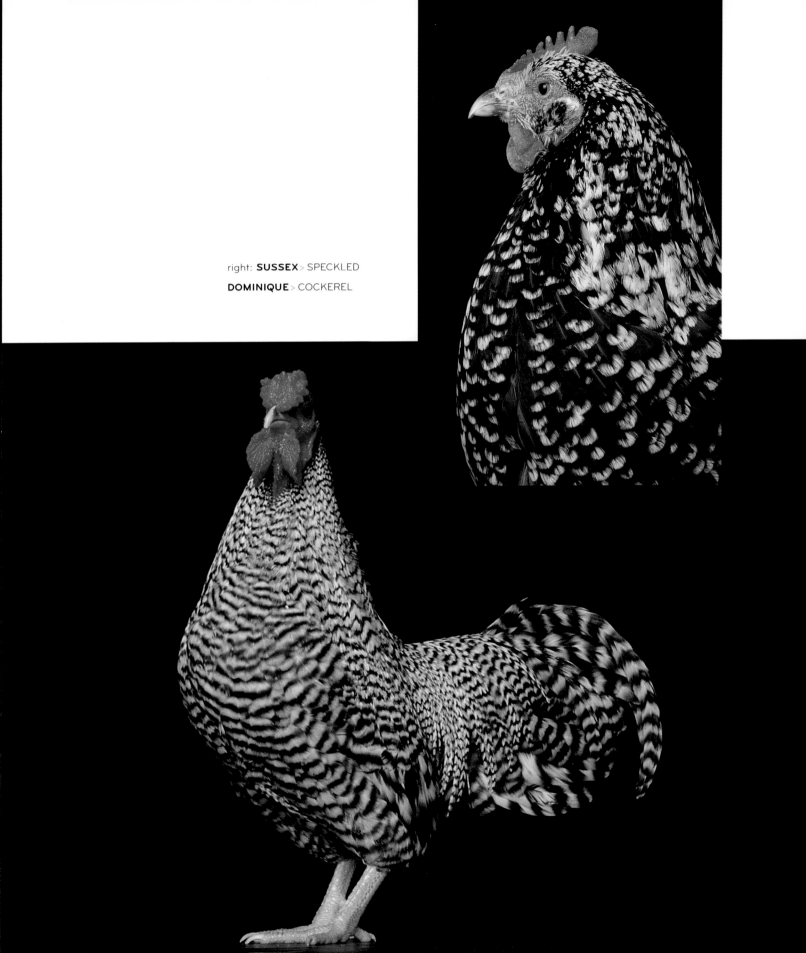

right: **SUSSEX**>SPECKLED

DOMINIQUE>COCKEREL

Lace and Partridge Patterns

right: **WYANDOTTE**> DUN LACED

SEBRIGHT> GOLDEN

opposite: (top) **PLYMOUTH ROCK**> SILVER PENCILED

PHOENIX> SILVER HEN

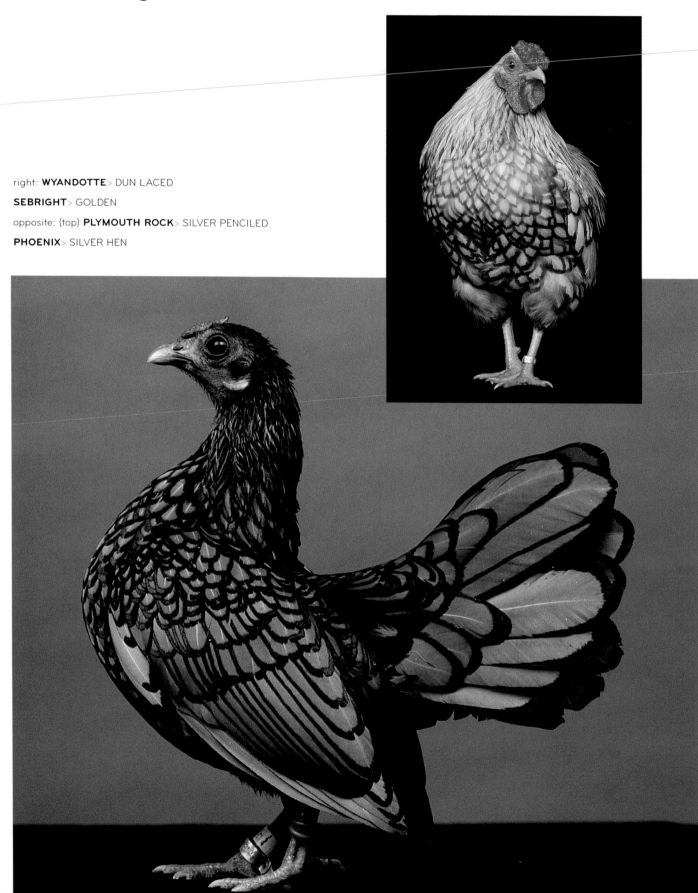

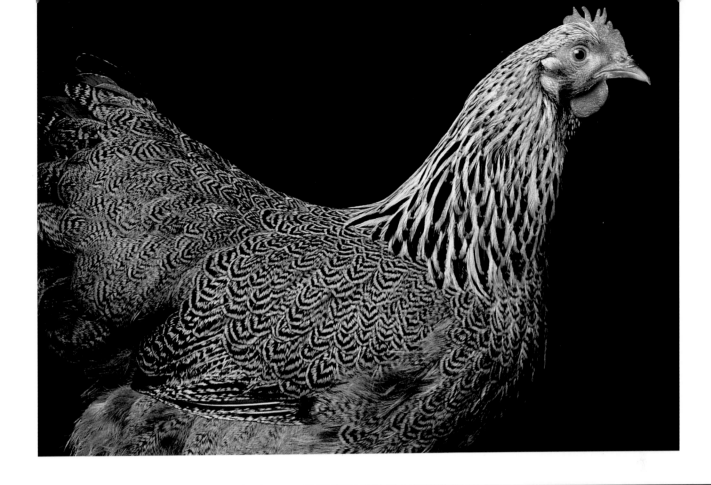
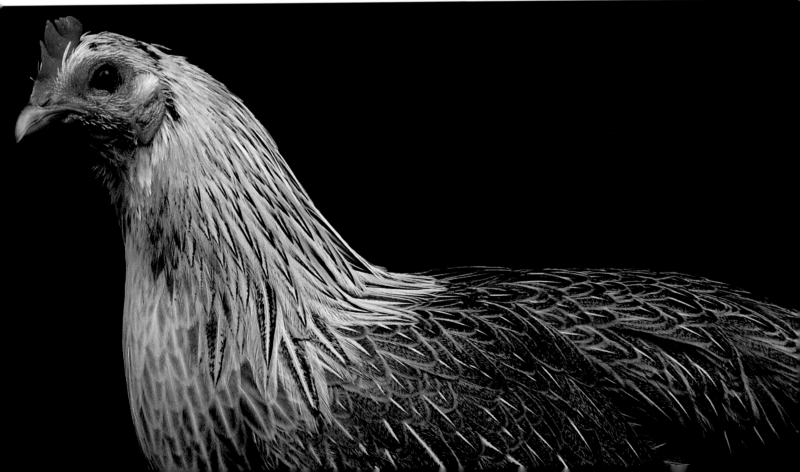

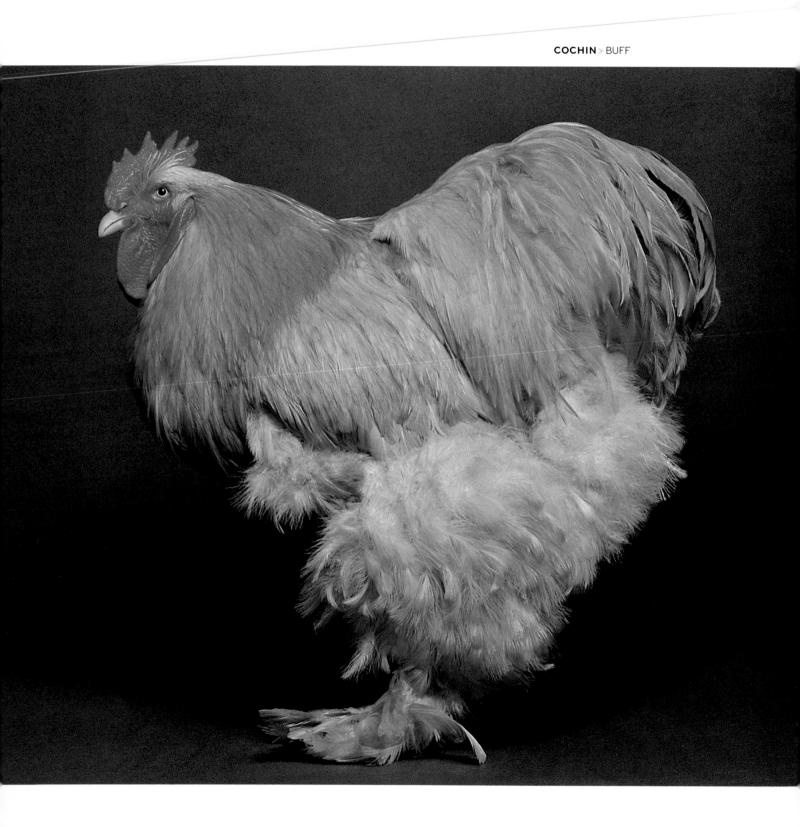

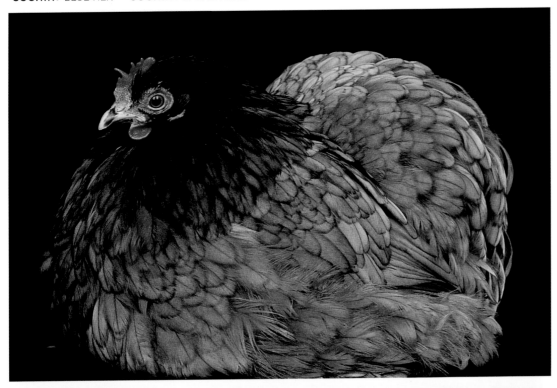

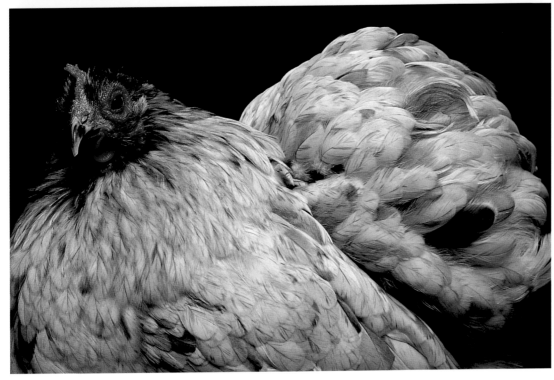

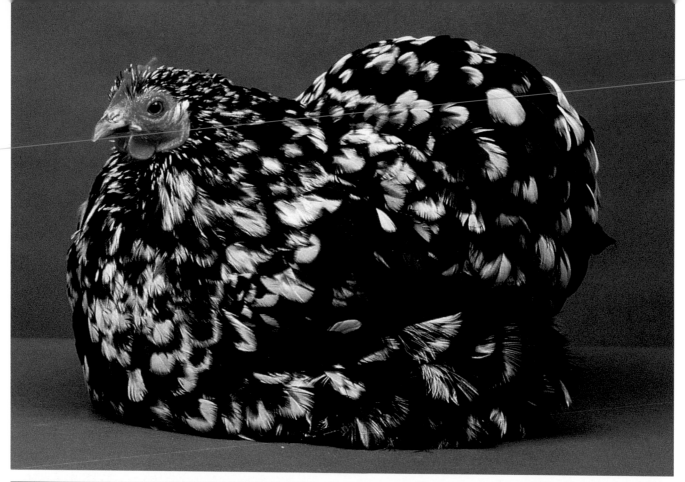
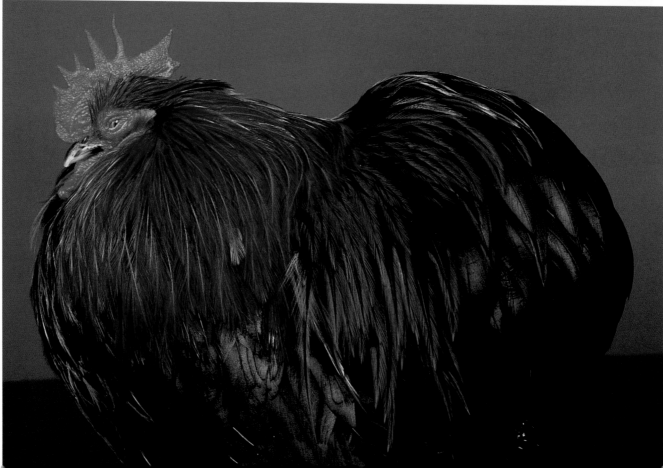

opposite: **COCHIN** > MOTTLED **COCHIN** > PARTRIDGE

COCHIN > WHITE PULLET

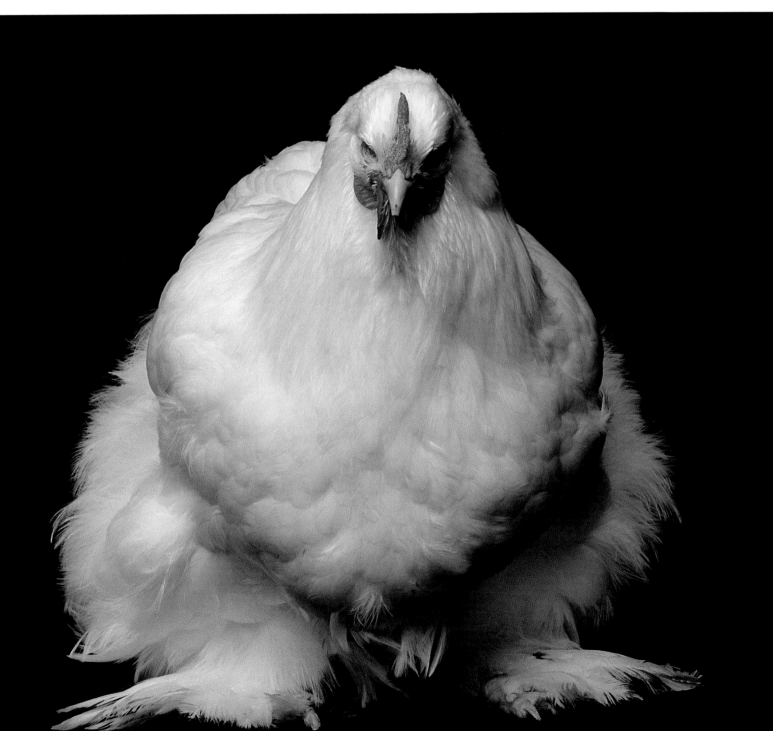

CHICKEN COUPLES

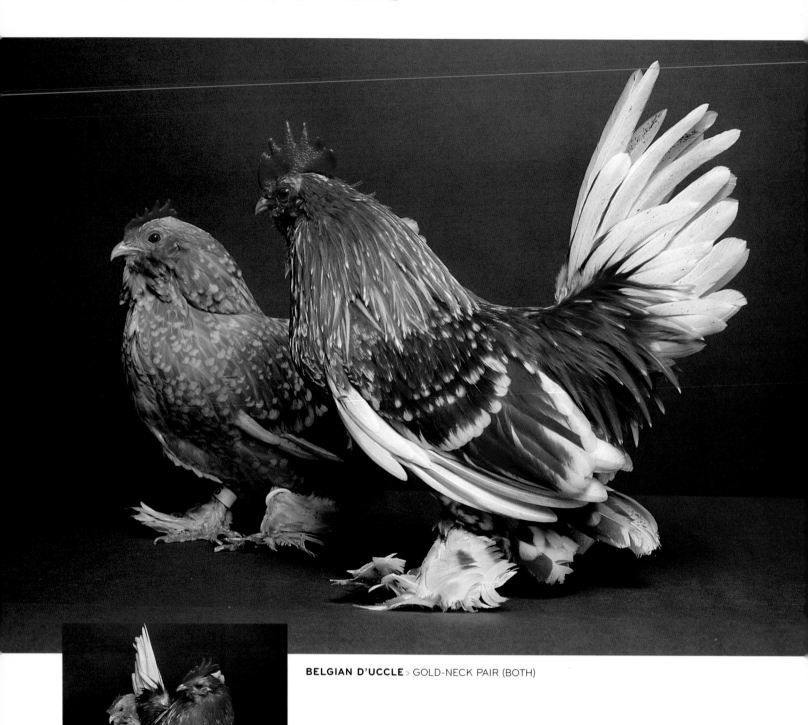

BELGIAN D'UCCLE > GOLD-NECK PAIR (BOTH)

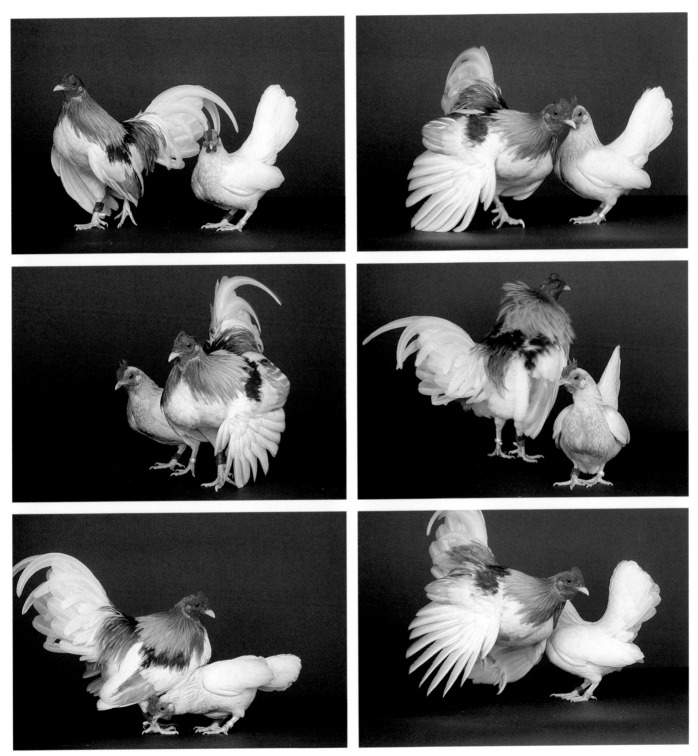

OLD ENGLISH GAME > RED-PYLE PAIR

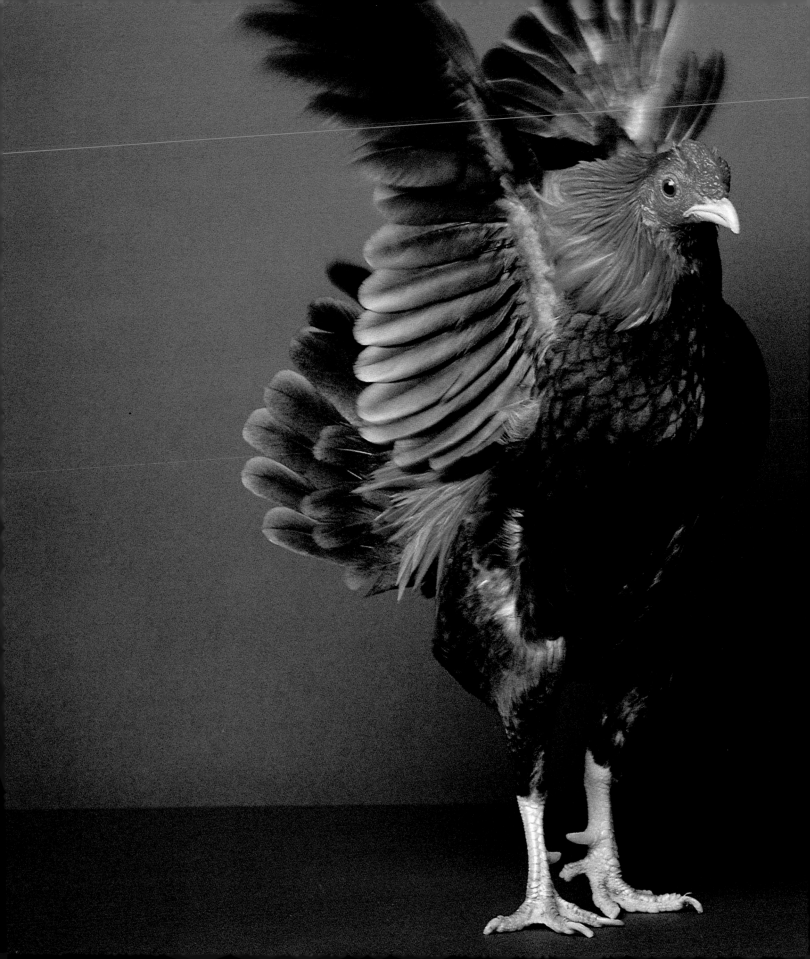

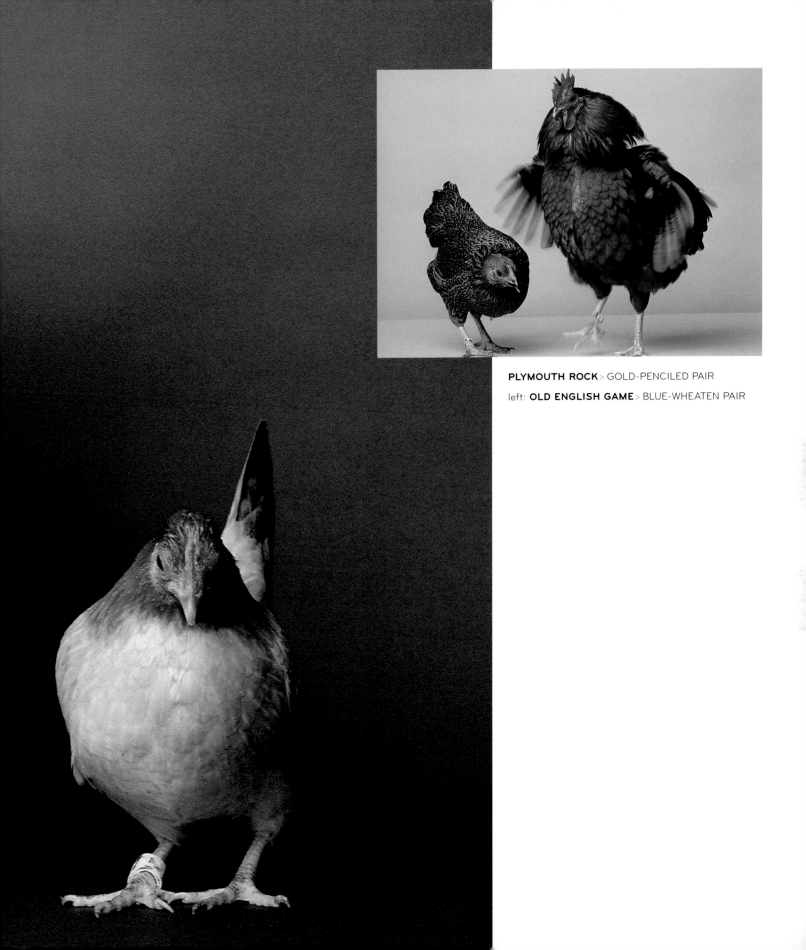

PLYMOUTH ROCK > GOLD-PENCILED PAIR

left: OLD ENGLISH GAME > BLUE-WHEATEN PAIR

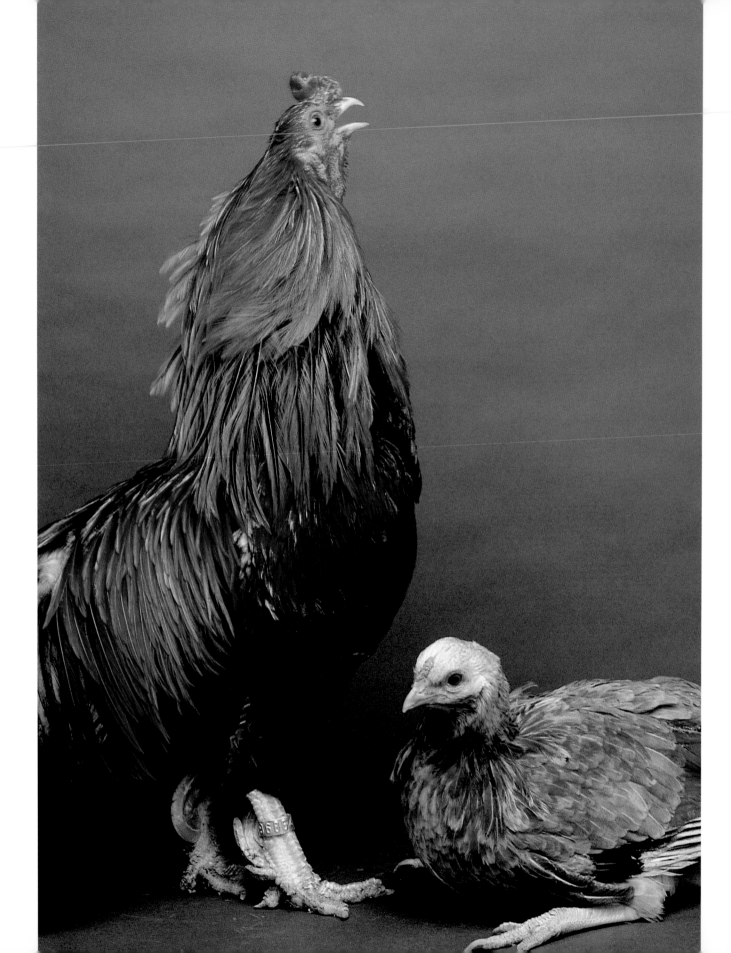

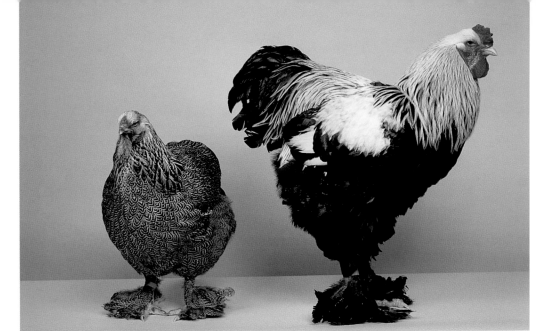

opposite: **CUBALAYA**>
BLACK-BREASTED RED PAIR

top right: **BRAHMA**>
DARK PAIR

center: **BELGIAN D'ANVERS**>
SILVER-QUILL PAIR

bottom: **PLYMOUTH ROCK**>
SILVER-PENCILED PAIR

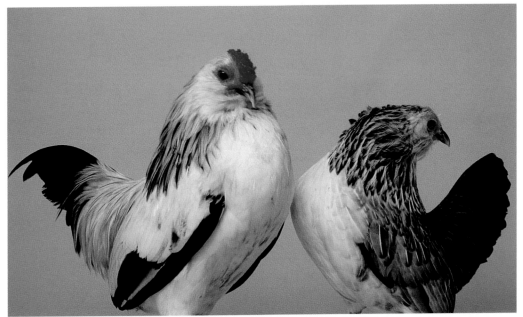

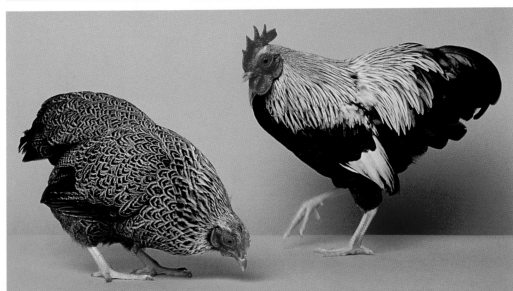

ARAUCANA

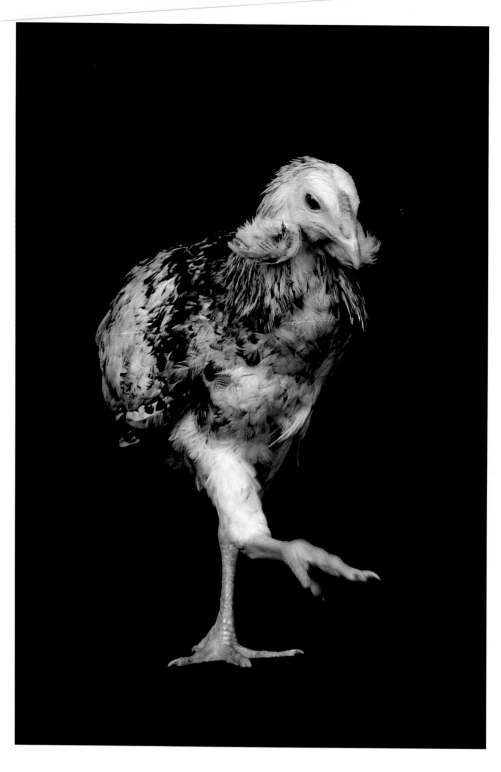

ARAUCANA > RUMPLESS, MOTTLED

opposite:
AMERAUCANA > BUFF HEN

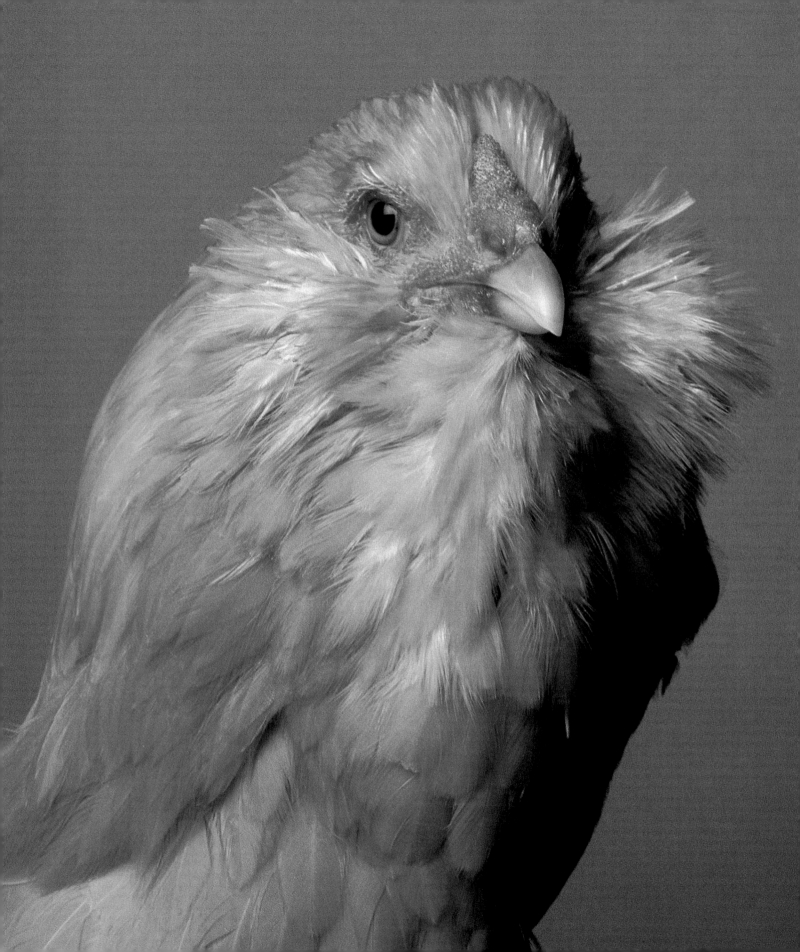

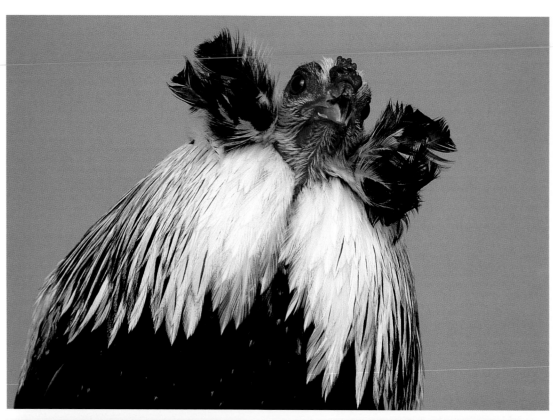
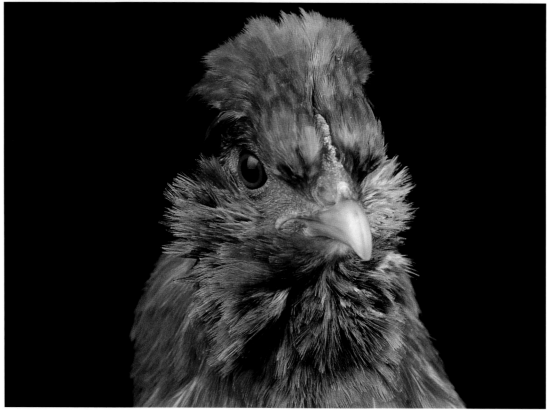

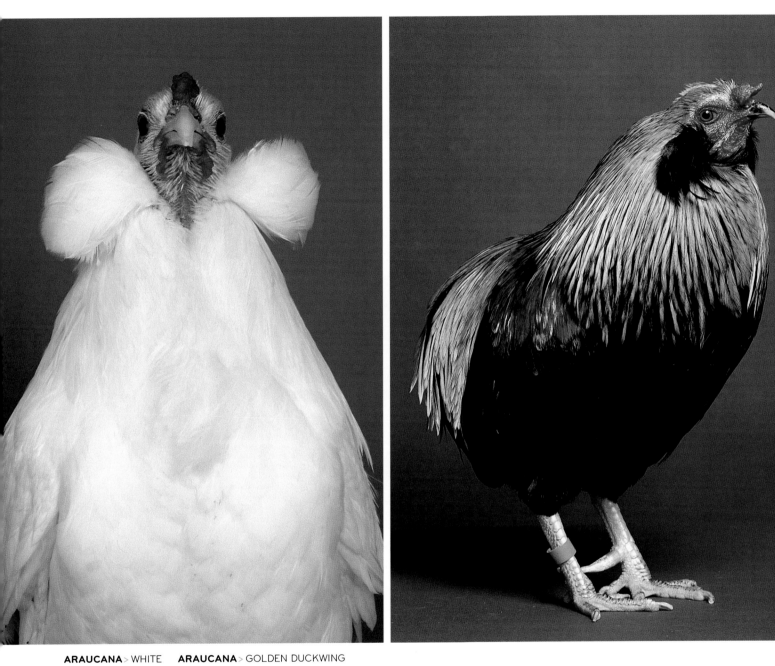

ARAUCANA > WHITE **ARAUCANA** > GOLDEN DUCKWING

opposite: (top) **ARAUCANA** > SILVER DUCKWING bottom: **AMERAUCANA** > BUFF HEN

BEARDS AND WHISKERS

FAVEROLLES > SALMON **FAVEROLLES** > SALMON HEN

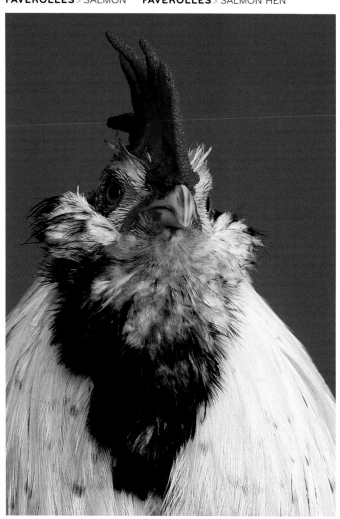 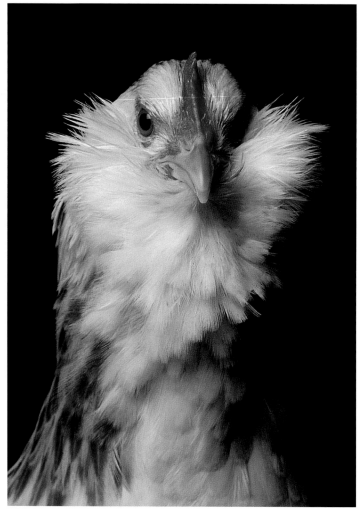

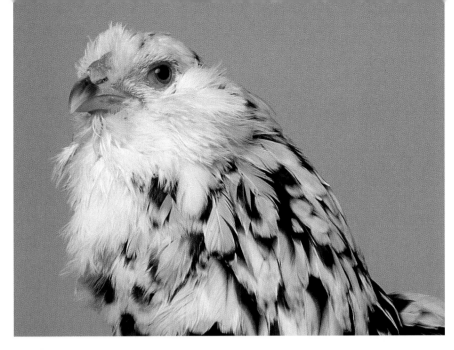

RUSSIAN ORLOFF> SPANGLED

OWLBEARD> WHITE-SPANGLED BUFF

OWLBEARD> SILVER SPANGLED

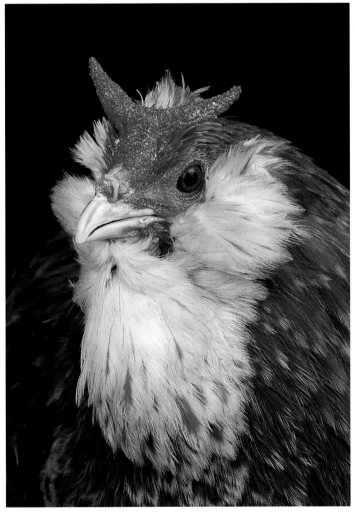

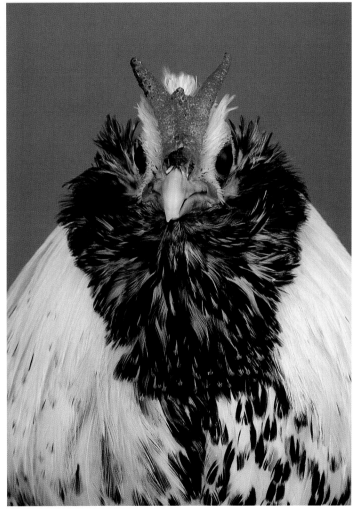

CRESTS

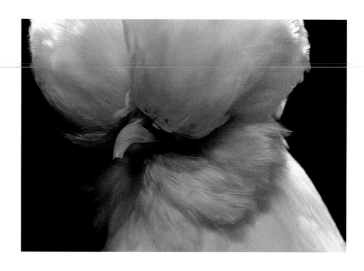

above: **SULTAN** > WHITE **BRABANT** > CUCKOO **BRABANT** > WHITE

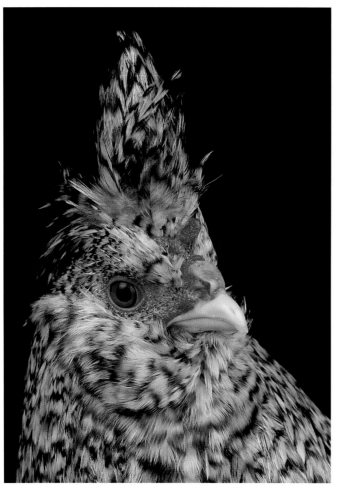

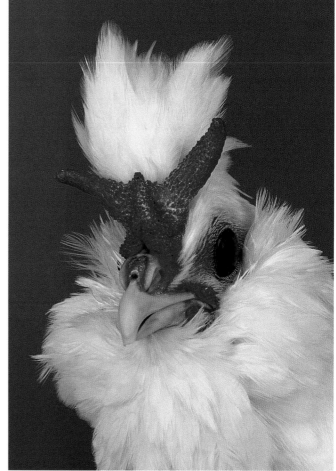

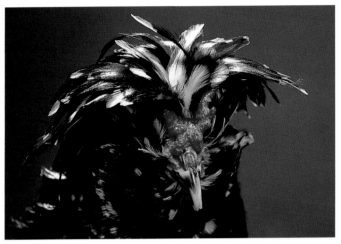

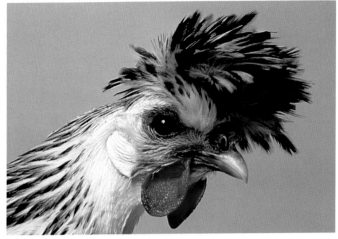

HOUDAN> MOTTLED **APPENZELLER SPITZHAUBEN**> SILVER-SPANGLED HEN

HOUDAN> SPLASH **APPENZELLER SPITZHAUBEN**> GOLDEN-SPANGLED HEN

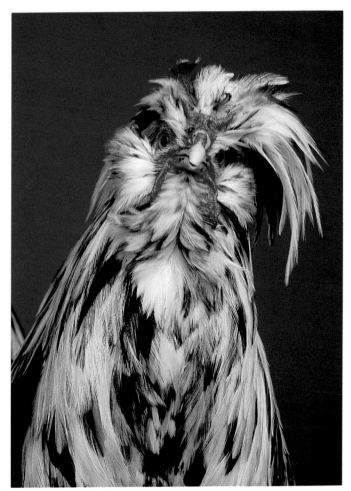

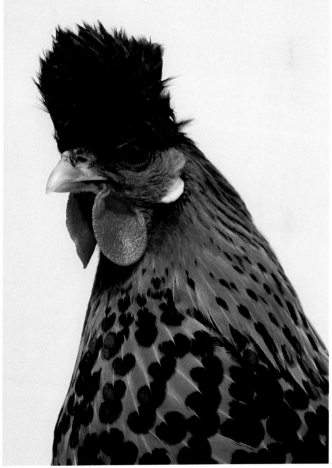

POLISH

clockwise from top left: **POLISH** > BEARDED, BUFF-LACED HEN **POLISH** > NON-BEARDED TOLBUNT OR HARLEQUIN

POLISH > NON-BEARDED, WHITE-CRESTED BUFF HEN **POLISH** > BEARDED, GOLDEN-LACED HEN

POLISH > NON-BEARDED, BLACK-CRESTED WHITE HEN

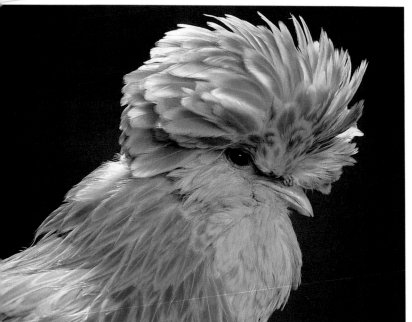

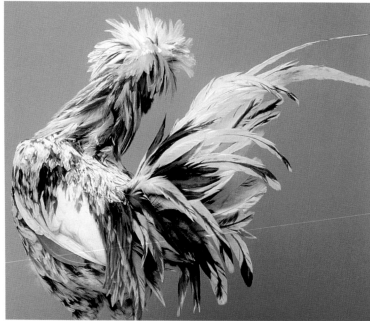

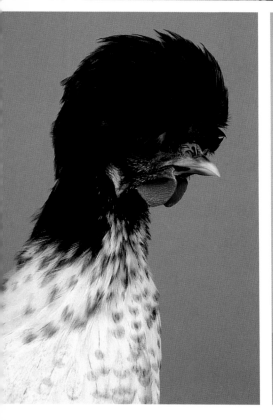

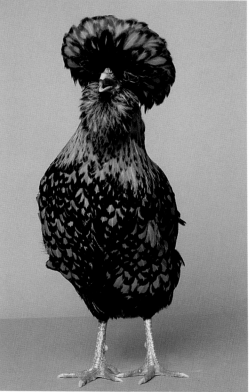

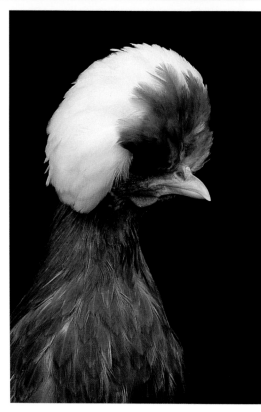

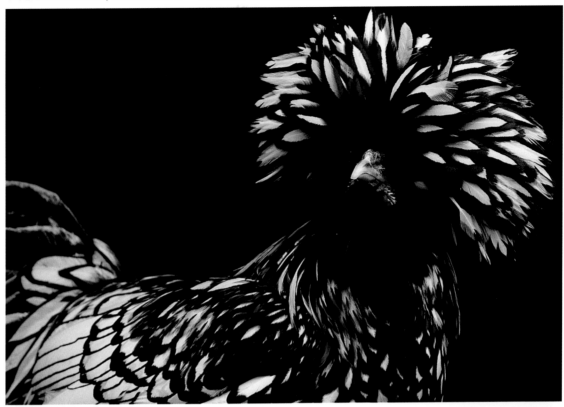

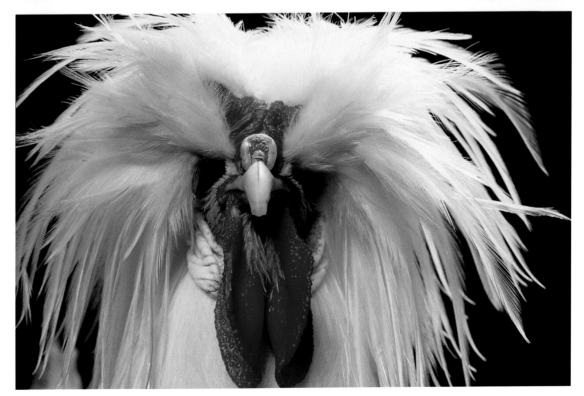

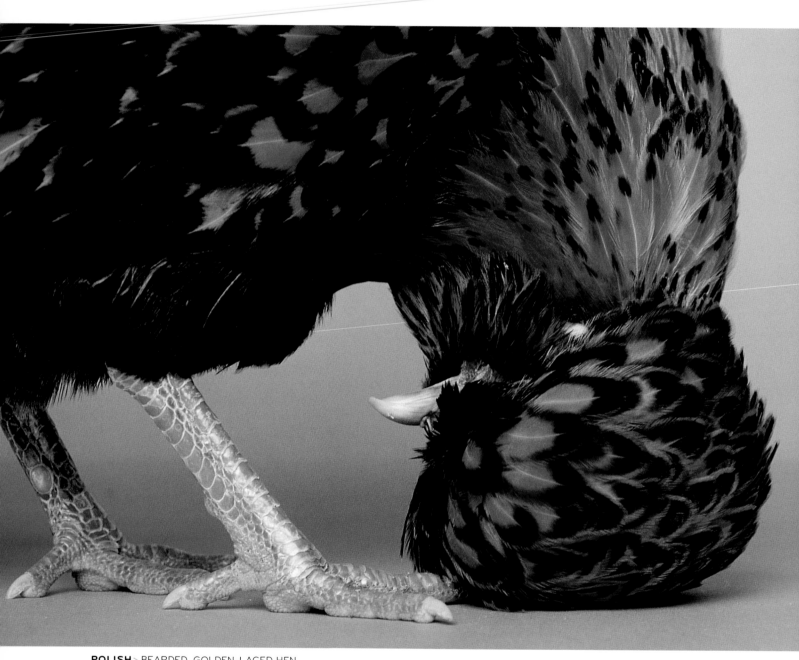

POLISH > BEARDED, GOLDEN-LACED HEN

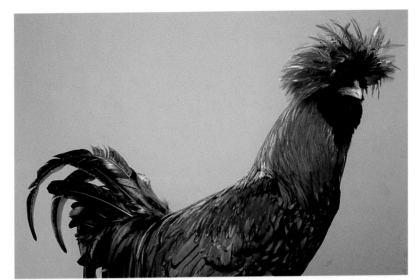

POLISH > BEARDED, GOLDEN-LACED COCKEREL

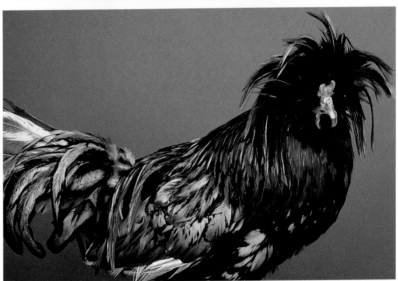

POLISH > BEARDED, GOLDEN-LACED

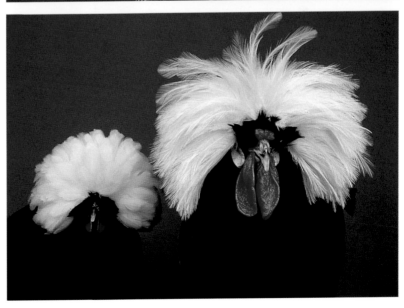

POLISH > NON-BEARDED, WHITE-CRESTED BLACK WITH YOUNG PULLET

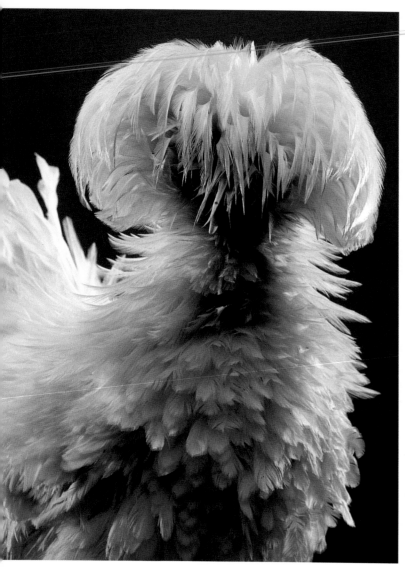

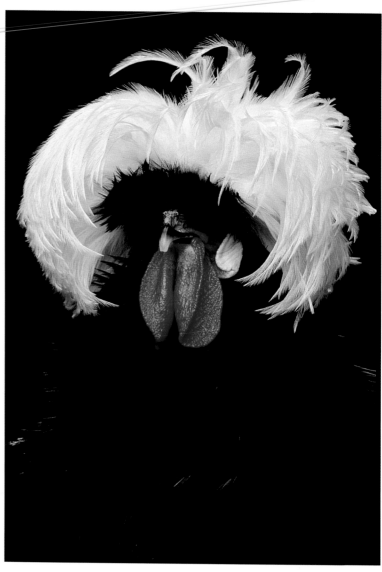

POLISH FRIZZLE> BEARDED, WHITE COCKEREL **POLISH FRIZZLE**> NON-BEARDED, WHITE-CRESTED BLACK COCKEREL

opposite: (top) **POLISH FRIZZLE**> BEARDED, WHITE **POLISH FRIZZLE**> BEARDED, CHAMOIS

overleaf, left: **POLISH FRIZZLE**> BEARDED, CHAMOIS **POLISH FRIZZLE**> BEARDED, BLUE HEN

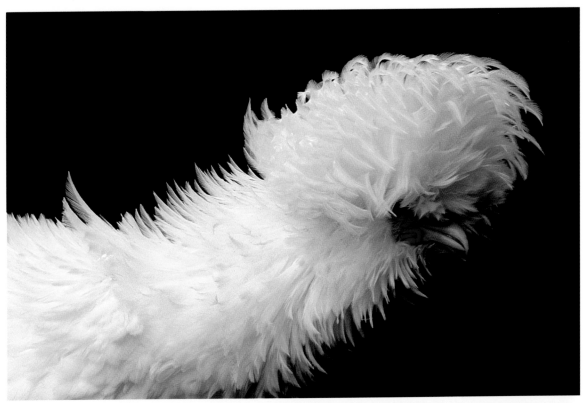
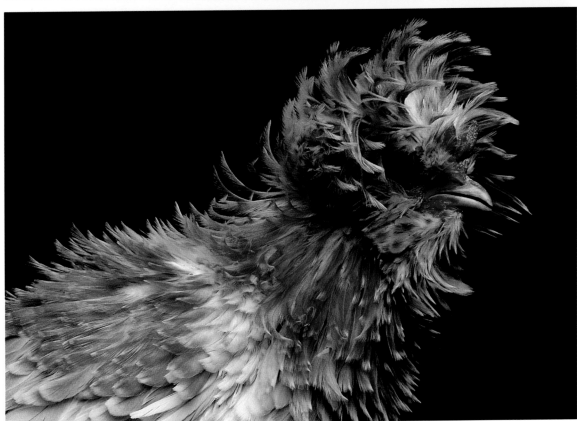

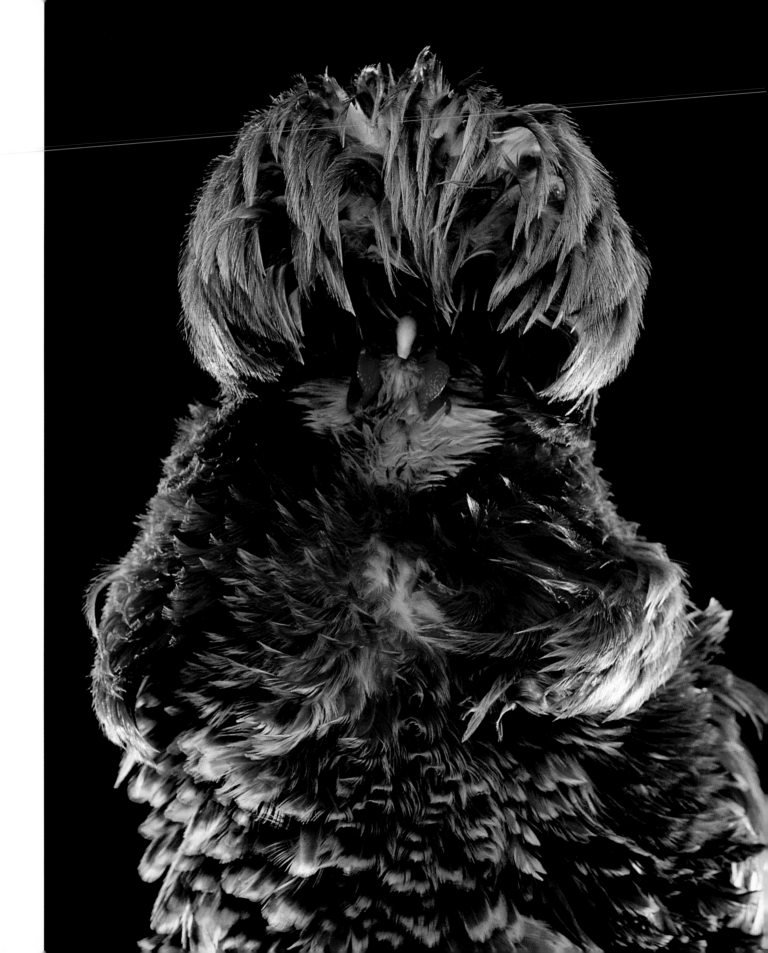

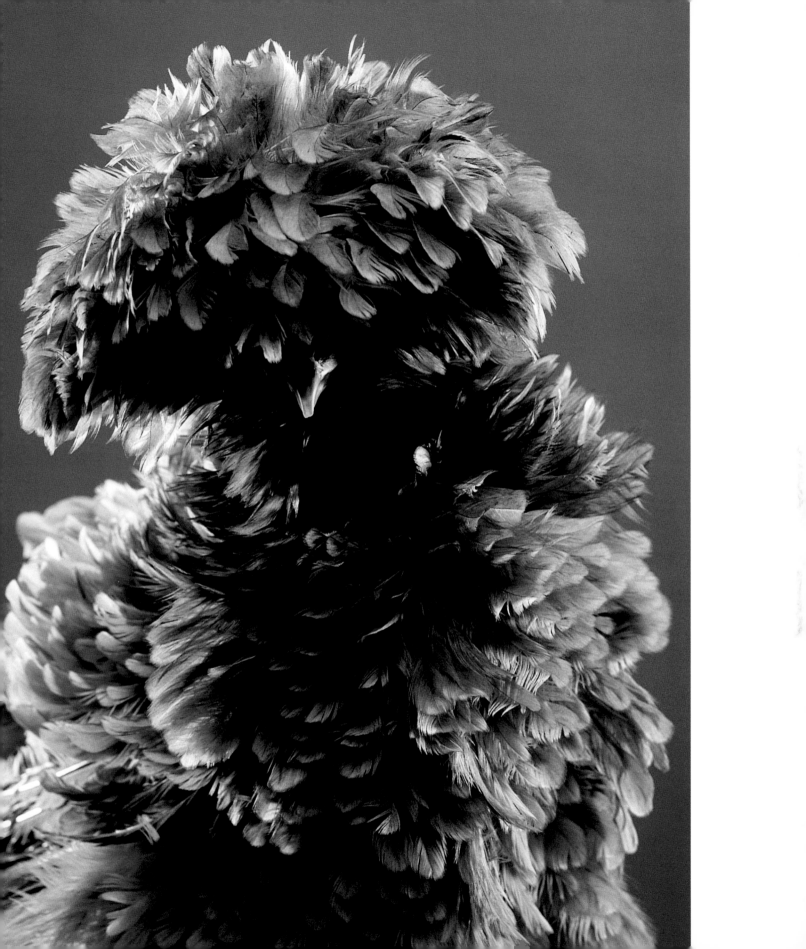

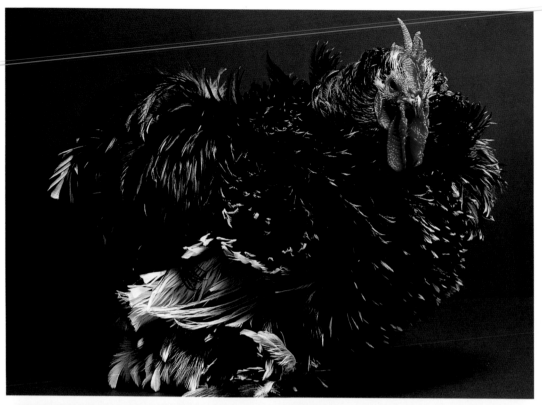

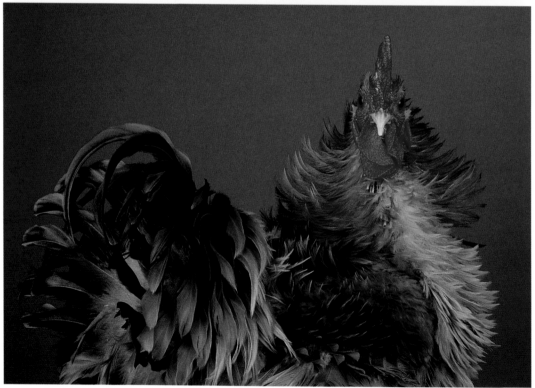

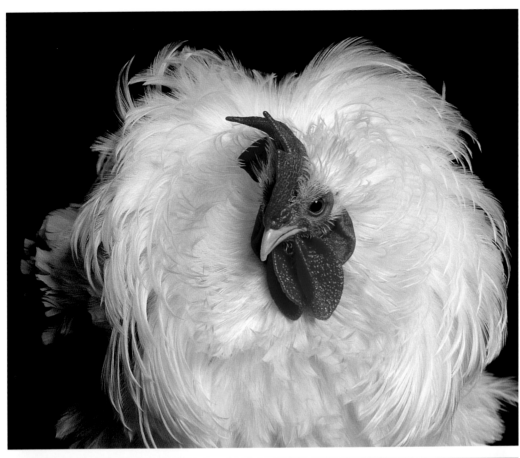

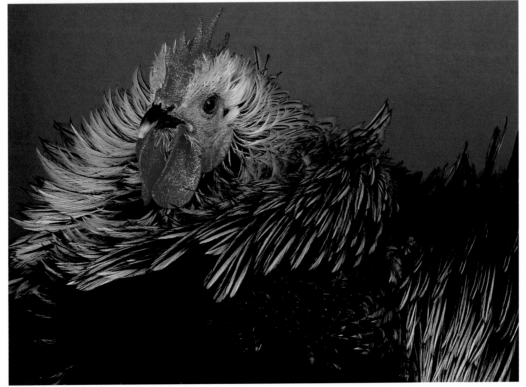

COCHIN FRIZZLE> WHITE
COCHIN FRIZZLE> BIRCHEN

SILKIES

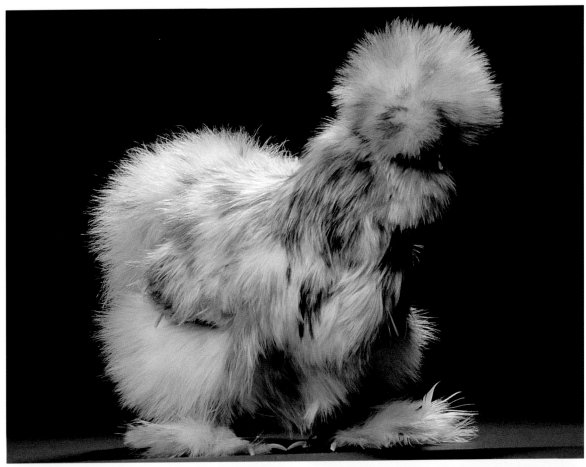

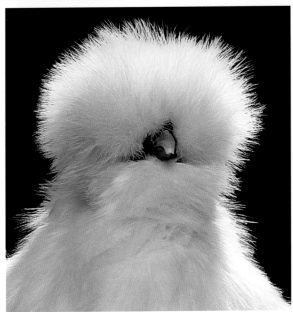

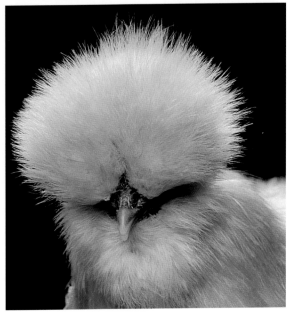

opposite: **SILKIE** > BEARDED, GRAY HEN

SILKIE > BEARDED, SPLASH PULLET

SILKIE > BEARDED, WHITE HEN **SILKIE** > BEARDED, BUFF HEN

SUMATRA > BLACK

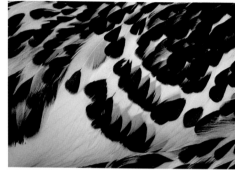

HAMBURG > SILVER SPANGLED

JAPANESE > BLACK-TAILED BUFF

AMERAUCANA > BLUE WHEATEN

BRAHMA > DARK HEN

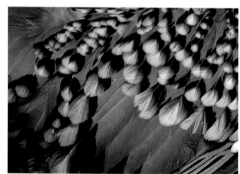

BELGIAN D'UCCLE > MILLE FLEUR HEN

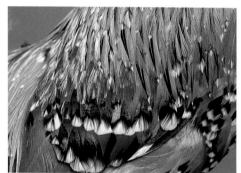

BELGIAN D'UCCLE > MILLE FLEUR

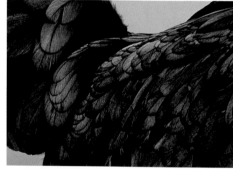

JAPANESE > BLUE

JAPANESE > BLACK

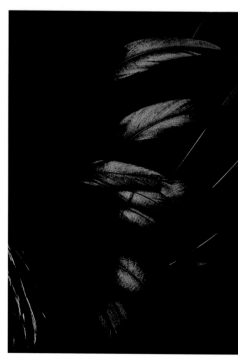

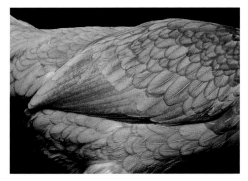
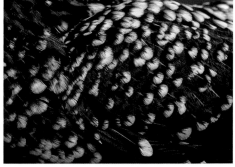

OLD ENGLISH GAME > BLUE-BREASTED RED PULLET **SUSSEX** > SPECKLED

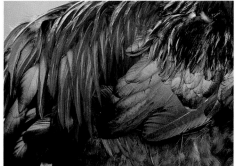
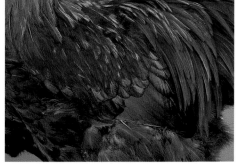

PLYMOUTH ROCK > PARTRIDGE **WELSUMMER**

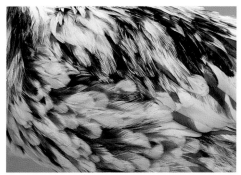
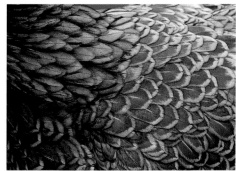
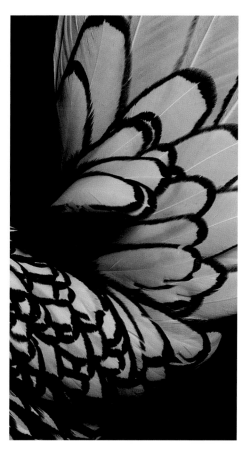

POLISH > TOLBUNT OR HARLEQUIN **WYANDOTTE** > BLUE LACED

SEBRIGHT > SILVER

About Chickens

The concept of exhibiting exotic breeds of chickens is fairly recent, dating from the middle of the nineteenth century, when a few unfamiliar breeds entered Europe and the Americas from the Far East. People were intrigued. Most assumed they had a good idea what roosters and hens looked like, and suddenly they were faced with creatures that were splendidly different but also evidently of the same species.

Farmers saw the possibilities of the imports, most of which were very large and therefore carried more meat. Some laid eggs throughout the winter, and others were tolerant of temperature extremes. Brown eggs were a novelty that fetched higher prices, and even today many assume that they are somehow more "natural" than the white ones. Fortunately, the imported chickens had few inhibitions about appreciating the charms of the domestic breeds, and vice versa, regardless of differences in size, shape, and color. Thus, breeders were able to experiment to develop birds with combinations of desirable commercial traits.

There emerged a whole new class of breeder—the enthusiast who just wanted to collect, admire, and exhibit strange and beautiful birds. This new attitude also had the effect of opening people's eyes to the variety and quality that already existed in their own domestic breeds. Although these chickens weren't primarily destined for the oven and the table, the birds weren't exactly family pets either. To some extent the owners regarded their beautiful chickens in the same way they might enjoy prize blooms in a flower garden: as living things that needed to be nurtured and cared for and that in return would provide owners with aesthetic pleasure and a degree of creative satisfaction.

In the century and a half that followed, we have seen the rapid development of new chicken breeds, for which we have a fairly well-documented record. Prior to about 1840, however, historical scholarship about chickens is not extensive. We can go back to around 3,000 B.C. for evidence of domesticated chickens in China. It is thought that these breeds may have originated in India, where, ironically, hard archaeological evidence of chickens dates back only to 2,000 B.C. Chickens appear occasionally in the art and writing of ancient Greece. It is possible that Persian soldiers on military campaigns in India had brought birds back to their land, and that in turn conquering Greeks brought them west from Persia. We also know that different breeds of chickens existed within the Roman Empire and that the same had been true in some Mediterranean countries prior to the rise of the Romans.

When the conquering Romans arrived in Britain two thousand years ago, they were surprised to find some chickens being used for "sport" rather than for meat and eggs. Cockfighting was popular in many countries, and, because warfare was often a part of everyday life in various parts of the world, there was an understandable respect for these little warriors with so much courage and tenacity. (One can see this respect reflected in the names of two of the weight classes used in boxing, *bantam* and *featherweight*). Some of the current exotic breeds are descended from fighting birds, and many remain aggressive to this day. In these cases one either has to keep males apart or to allow a natural pecking order (literally) to establish itself through barnyard bravado and battles.

In 1849, Britain banned cockfighting, giving an immediate boost to the interest in breeding ornamental chickens. There had already been some interbreeding of certain aggressive and powerful Asian breeds to produce better fighting birds, and now much of this interest and expertise was diverted to the

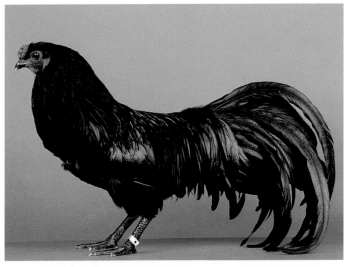

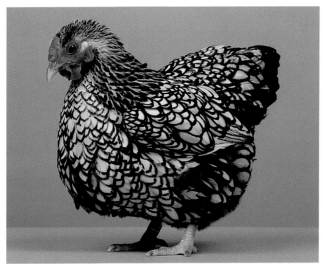

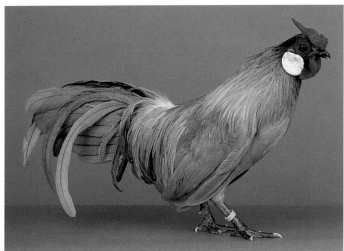

clockwise from top:

SUMATRA> BLACK

WYANDOTTE> SILVER-LACED PULLET

CUBALAYA> GOLDEN DUCKWING

ROSECOMB> PEARL GRAY

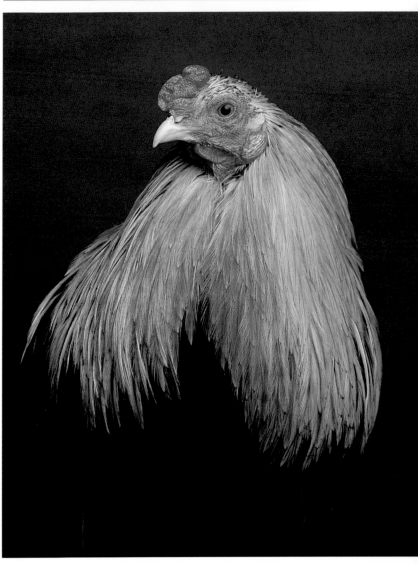

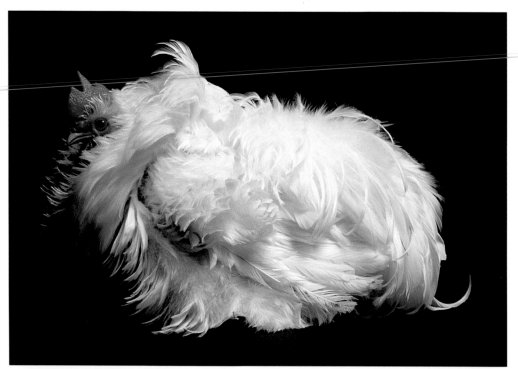

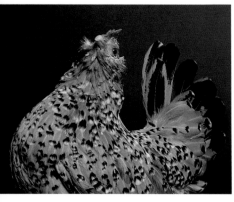

clockwise from above:

BELGIAN D'UCCLE>
MILLE FLEUR HEN

COCHIN FRIZZLE> WHITE

BRAHMA> DARK

CORNISH> WHITE

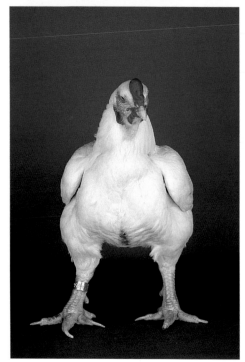

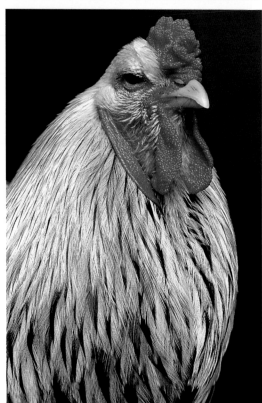

development of exhibition birds. (Of course, a little discreet cockfighting continued, but the severe penalties for those who were caught were a deterrent.) In addition, chicken shows did involve competition and offered prospects of financial gain; prizes were awarded, and successful birds added value to one's breeding stock, so this alternative to fighting was not an unwelcome substitute.

The first known major poultry show was staged in 1845 at London's Regents Park Zoo, a place filled with interesting wild creatures. Those who attended were not disappointed. Four years later, in 1849, the United States followed with its first breed show, in Boston.

Queen Victoria was an early enthusiast. She had a fine poultry barn built at Windsor for her prized Cochins and Langshans from China and, later, her Brahmas from India. Other breeders also built housing for their handsome fowl. The creatures who had been barnyard scavengers for centuries were now being well fed and enjoying better living quarters. Victorian times saw an explosion of interest in poultry, and the big shows attracted large and eager audiences.

In the subsequent years, countless thousands of shows of all sizes have been held in many countries. Trying to keep up with shows around the world today would be impossible. In Holland alone, for example, about six hundred shows a year are staged by four hundred and fifty different clubs. At many events, geese, turkeys, ducks, and, occasionally, guinea fowl are included with the chickens. European shows might also include doves, pheasants, and even rabbits and guinea pigs. At big agricultural fairs that feature various types of farm animals, the poultry section is often the most surprising and the most popular, providing many people their first glimpse of what chicken breeders have accomplished during the past century and a half.

Several countries established national associations that undertook to set show standards for each breed. Like similar organizations governing dog and cat shows and livestock events, they keep track of new breeds as they are established. With poultry, it can be challenging to keep pace with the rapid rate of successful breeding experiments. For example, the German poultry association currently recognizes fewer than half the five hundred breeds that poultry photographers Josef Wolters and Rudiger Wandelt have recorded. Hans Schippers, a biologist and the Dutch poultry authority, estimates that if one were to consider all color possibilities for all breeds, one could come up with a total of seven thousand different varieties. If a show judge were to then split these into adult male and female birds, and also into birds younger than a year old, one could in theory distinguish twenty-eight thousand separate varieties.

Most shows are competitions, with placements and awards being decided in categories designated by the show organizers. Those winners then are judged against each other in broader classifications, culminating in a "best in show" award. These events, particularly the smaller ones, are attended primarily by the owners of the chickens on display. For the owners it is a pleasant opportunity to meet fellow enthusiasts and their birds, to share advice, and, in many cases, to arrange sales, purchases, and exchanges. Usually, outside visitors are attracted only to the more prestigious events, such as the huge annual show for cockerels and pullets held in Hanover, Germany, and the British National Show in Stoneleigh. In 1995, a show in Nuremberg, Germany, boasted a total of more than seventy thousand birds, a record that will probably be beaten before this book appears. There is a lull in show activity in the summer because few birds are "in good feather" during the hottest part of the year.

Human intervention has dramatically accelerated the interbreeding of chickens to combine different features of one breed with those of another, and then usually adding a third, and a fourth, and more. This is being done at a rate that would be inconceivable in the wild. Birds that are not domesticated seem to be extremely particular about their mating partners. In looking through a good bird-identification book,

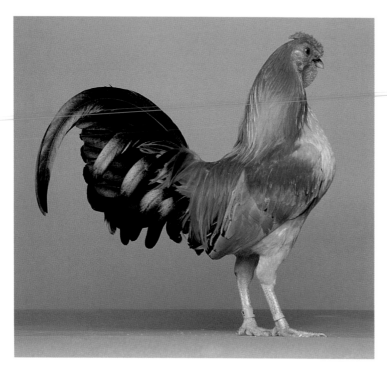

NANKIN

for example, one can see pages of warblers with only minor distinguishing markings. Apparently these small differences are sufficient to inhibit mating. Chickens lack these prejudices, although there are some exceptions. For example, crested birds shun non-crested varieties, and the more ancient breeds will not mate with modern, "utility" birds. But while we have fast-forwarded evolution, we have done so in ways that have replaced "survival of the fittest" with "survival of the prettiest" or, in some cases, apparently, "the survival of the strangest." While commercial chicken operations continuously work toward producing varieties with optimal market value, the number of different types they produce is dwarfed by the number of variations produced by hobby owners.

Manipulating size has long been popular among chicken fanciers. A few breeds exist solely as Bantams, with no full-size equivalents, but the majority were deliberately bred as downsize versions of bigger birds. Some experts insist that these should be called *miniatures* rather than *bantams*. The word *bantam* appears to come from a province on the Indonesian island of Java, the original source of some small chickens. One can see the appeal of these small birds just as one can appreciate the attractiveness to many people of a toy poodle or a miniature schnauzer. Bantams take up less space, eat less food, are more easily handled, and they seem somehow more charming. One hesitates to use the word cute when describing a proud and aggressive rooster, but it often seems appropriate in the case of Bantams.

Even with all the interbreeding, identifying the wild ancestor of the domestic chicken seems to have been surprisingly easy. Nineteenth-century scientists and naturalists, including Charles Darwin, were aware of five ancient species of wild fowl in Southeast Asia that were possibilities. The Red Jungle Fowl seemed to be the strongest candidate. Fortunately, this bird still exists, although the specimens that are seen in the West may not have a totally uncontaminated hereditary link to the birds of five thousand years ago. Even those captured in the wild in Southeast Asia may incorporate occasional instances of "breeding back" with village chickens somewhere in their genetic history. In any event, recent DNA testing confirms that the Red Jungle Fowl is indeed the true Adam of present-day chickens.

Notes on the Ornamental Breeds

The following breeds, listed alphabetically, are featured in this book:

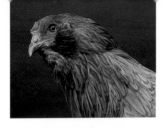

In the 1970s, breeders came up with a more practical version of the Araucana: the resulting **AMERAUCANA** retains the tinted egg color but provides more meat than its ancestor. This breed has ear muffs, rather than ear tufts, and also wears a beard.

Although the **ANCONA** is not from coastal regions of Italy, it was named after the seaport from which specimens were first shipped to England. Like the Leghorn, to which it is related, the Ancona is an excellent egg layer. Although the breed has been in the United States since the 1880s, it is seldom seen at poultry shows today.

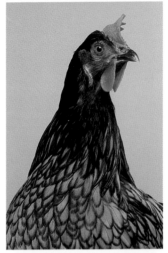

The **ANDALUSIAN**'s slate-blue color and subtle blue cast was originally achieved by crossing white birds with black. Over the years, breeders have worked to develop the attractive lace pattern. Coming from Andalusia in the southernmost part of Spain, this breed has been recognized in the United States for more than 130 years.

The **APPENZELLER SPITZHAUBEN** is not listed in the *1998 American Standard of Perfection*, but it has recently been recognized in a few European countries. The breed seems to have been a hardy survivor developed over several centuries in the Appenzell territory of Switzerland; the second part of its name comes from the pointed bonnet that is traditional in the area. The late Mrs. Pamela Jackson, with the help of her sister, the Duchess of Devonshire, imported, bred, and distributed these birds with enormous enthusiasm. They began their efforts in England in the early 1960s, and in fewer than thirty years the breed had acquired a loyal following.

The **ARAUCANA** from South America is unique in laying eggs that have a faint green or blue tint. The native Araucas resisted the mating of their birds with those of the conquering Spaniards, thus preserving the character of these chickens. They feature conspicuous feather tufts on either side of the neck. Rumpless Araucanas are popular, although technically this is a subvariety called the Colonca.

The **ASIL**, or Aseel, is an Indian bird with a two-thousand-year heritage of cockfighting. Today's Asil still has all the right attributes; it is muscular, aggressive, tenacious, and energetic. Asil means "noble and pure," and the breed has an air of aristocratic authority.

For the **AUSTRALORP**, see Orpington.

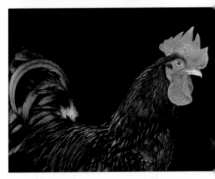

The **BARNEVELDER** was the result of a plan to develop a large and useful bird that would lay the brown eggs that were appreciated in Britain. The egg color has gradually faded in some countries, and the breed is now appreciated primarily as a show bird. The Dutch are working to reestablish the importance of a dark brown egg. Barneveld is the center of a major chicken-breeding area and is also the site of Holland's fine poultry museum.

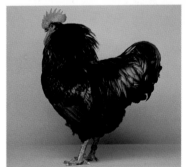

The **BELGIAN D'ANVERS**, known in Britain as the Barbu d'Anvers, is like a confident terrier, relying on speed and boldness and willing to challenge all comers. It can be distinguished from the Belgian d'Uccle by its unfeathered legs and its rosecomb. Both types stand boldly upright. The whiskers give its face the appearance of a small rodent.

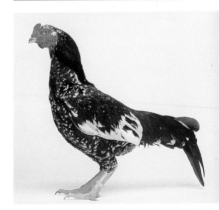

from top: **AMERAUCANA** > BLUE WHEATEN **ANDALUSIAN** > HEN **BARNEVELDER** > DOUBLE LACED
AUSTRALORP > BLACK **ASIL** > MOTTLED

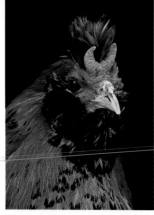

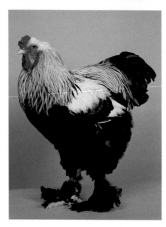

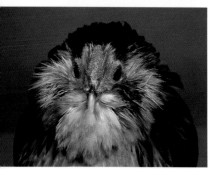

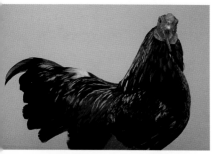

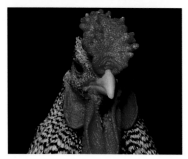

The **BELGIAN BEARDED D'UCCLE** (the Barbu d'Uccle in Britain) is like the Belgian d'Anvers except that it has feathered legs. Initially, the exotic specimens with the Mille Fleur coloring of the d'Uccle attracted the British and the Americans, and some people simply refer to these true Bantams by that designation instead of the name of the breed. The Golden Neck variety is similar and also very attractive, though with a narrower color palette.

The **BRABANT** was common in certain parts of Belgium and was also to be seen on farms in Northern France and parts of Holland. It is presumed to be an extremely old breed, not created from any known crosses. Brabant eggs have unusually strong shells.

Although Europe and the Americas had digested the startling size of the Cochins and Langshans a few years previously, the arrival of the **BRAHMA** —with its great height and the calm dignity of the male—still created a stir. The first specimens, Light Brahmas, came to the United States in 1847. Six years later, a group of them was sent to Queen Victoria by a Mr. Burnham, who correctly assumed that his gesture would help to increase the popularity and prestige of the breed. At first the birds went by the name of Grey Chittagong and, later, Brahmapootra, after the river in India that may have been near their place of origin. The latter name was eventually shortened to Brahma.

The **CAMPINE**, from Belgium, is known to have bred true to type for many centuries. The Campine area near Antwerp was never particularly fertile, which accounts for the modest size of the birds. Like some other breeds that caught on as exhibition birds, some of its utilitarian qualities were reduced in the quest for beauty.

This French-sounding name for a North American breed can be explained by its origin in Quebec, Canada. **CHANTECLERS** were bred to withstand the cold of harsh winters, and the parts of the body not covered by feathers— the comb, wattles, and earlobes—are suitably small. Their ancestry includes various breeds from New England as well as Leghorn and Cornish.

The **COCHIN** was initially known as the Shanghai, and then as the Cochin China in honor of its homeland. The arrival of these large round birds in the United States and Britain in the mid-1840s created a sensation. They weighed ten to twelve pounds but looked even heavier because of their ample soft feathers. The ginger color of the first imports was also a novelty.

The **CORNISH**, known in England as the Indian Game, is descended from Asils and Malays that have been combined with birds local to Cornwall, at the southwest tip of England. In spite of its bulldog figure, the Cornish was never a fighting bird. Its extremely broad breast has made it popular as one of the elements in commercial hybrids that furnish a good amount of white meat.

For **CROAD LANGSHAN**, see Langshan.

The **CUBALAYA** is indeed from Cuba, where it was bred from Malays that had been brought to the island from the Philippines and Florida. Subsequently some European blood was added. The Cubalaya has an unusual stance, with the neck and shoulders held high and forming the top of a diagonal line that slopes down through the back and the tail. This is a handsome bird with a wild and exotic appearance, and it has been recognized in the United States for more than sixty years. It is surprising, therefore, that one rarely sees Cubalayas at poultry shows.

DOMINIQUE, a very early North American breed, seems to predate the 1850s, when farmers started to keep records of the breeds contributing to mixed ancestry. It has been suggested that the Hamburg may be a major element. The distinctive cuckoo-feather pattern is made up of irregular black and white bars.

The **DRENTE FOWL** is a Dutch breed that appears to be pretty much unchanged over the last two hundred years. Archaeological research traces it to Roman times, and it is closely related to the Red Jungle Fowl.

BRABANT > GOLD SPANGLED **BELGIAN D'ANVERS** > QUAIL HEN **BRAHMA** > DARK

CHANTECLER > PARTRIDGE **DOMINIQUE** > COCKEREL

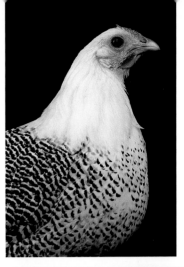

DUTCH BANTAMS appear to be among the oldest of the Bantams and are sometimes referred to as Old Dutch.

The **FAVEROLLES** originated in the French village of the same name. Faverolles is close to the town of Houdan (see below), and the two towns' chickens also seem closely related. The Faverolles also contains some Dorking and Brahma strains in its ancestry.

The **FRIESIAN**, from northeastern Holland, is another excellent egg layer. These birds are also capable of sustained (long-distance) flight.

Technically, a **FRIZZLE** chicken refers not to a breed but to a distinctive type of feathering that curls away from the body. Darwin observed that Frizzles were "not uncommon in India," where they are also called Caffie Fowl, and it is assumed that they originated there. Breeders must take care not to allow feathers to become too brittle and delicate, and every few generations a non-Frizzle bird has to be included in the mix to prevent this.

The **FRIZZLE POLISH** hybrid was conceived and achieved by Arie Boland of the Netherlands, and the result is a truly amazing creature. Many birds and many generations—not to mention intelligence, experience, and knowledge of genetics—were involved, plus quite a large sum of money—an estimated $20,000. Not only did Mr. Boland succeed in creating a unique breed, but he did so in several different colors.

The **HAMBURG** (or Hamburgh in Britain) is not actually from Germany but rather from Britain and Holland. The Lancashire Mooney and the Yorkshire Pheasant seem to be among its combined ancestors.

The **HOUDAN** is a general-purpose French breed prized as a layer of large eggs and for the quality of its meat. The town of Houdan is in southern Normandy, and the breed was once referred to in Britain as the Normandy Fowl, perhaps not distinguishing it sufficiently from the Crèvecoeur chicken, named for another,

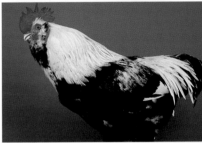

nearby town in Normandy. Darwin classified both these crested birds, together with the Polish (see below), as subspecies of the same breed. However, unlike the others, the Houdan has a fifth toe, suggesting a possible common ancestry with the Dorking.

JAPANESE BANTAMS, also known as Chabo Bantams, were imported to Holland in the seventeenth century, but for a long time they were rare because of Japan's insular trade policies. No other breed features a male holding its tail feathers so erect; often they come close to touching the back of the head.

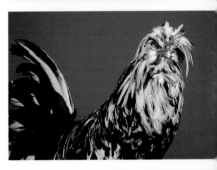

The **JERSEY GIANT** was developed in the American state of New Jersey, not the island of Jersey in the Channel between France and England, as some have assumed. Black Javas were bred to the enormous dark Brahma and the tall black Langshan for maximum size. The result is a bird approaching turkey weight—as much as thirteen pounds for a rooster and ten pounds for a hen. While the black Jersey Giants have been in existence since the 1880s, the blue and the white versions came much later.

As mentioned earlier, the **JUNGLE FOWL** are distinct species of pheasants, and not actually chickens. However, the Red Jungle Fowl is the ancestor of all the billions of domestic chickens in the world today. Like their domestic descendants, these pheasants are gregarious. Pure wild specimens can be hard to find today, because even in their native areas of Southeast Asia, **RED JUNGLE FOWL** have sometimes mated with domestic fowl around human settlements. Over the course of centuries, even millennia, these matings must have affected both species to some extent.

The breeding season is year round in the warm climate of Sri Lanka, where the **CEYLON JUNGLE FOWL** have adapted to different terrains and altitudes. Understandably, they prefer to nest where the vegetation is dense and to feed in more open land. The birds can become obese, and perhaps inebriated, when Nilloo berries are in season.

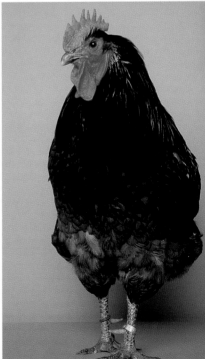

HAMBURG > SILVER-PENCILED PULLET **FAVEROLLES** > SALMON

HOUDAN > MOTTLED **JERSEY GIANT** > BLUE

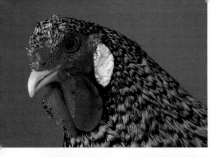

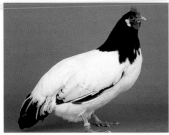

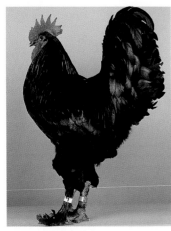

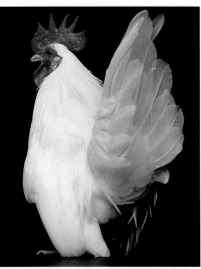

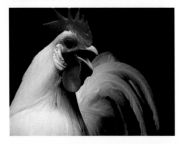

Native to Indonesia, the **GREEN JUNGLE FOWL** enjoy the warm coastal climate, and they suffered extensive habitat loss in the massive tsunami at the end of 2004. On the large island of Java, the particularly loud noise made by Green Jungle Fowl has prompted crowing contests, usually involving birds that are hybrids with domestic fowl.

The **GREY JUNGLE FOWL** of southern India tend to be more solitary than the other Jungle Fowl. An alternate name for the Grey is Sonnerat's Jungle Fowl. The birds have been hunted for their hackle feathers, which are valued by the makers of fly-fishing lures.

The Dutch breed known as the **KRAAIKOP** is unusual in that the shape of the head is like that of a crow.

The **LA FLÈCHE** is an excellent meat bird from a town of the same name in the Loire valley in France. It is related to the Polish and the Crève-coeur but, unlike those two, has no crest to diminish the effect of the "devil's-horn" split comb.

The **LAKENVELDER** is thought to be a German breed from Hanover and Westphalia but may be from Holland originally. It is believed to be related to the Belgian Campine. Mysteriously, it was once thought to have origins in Jerusalem.

The **LANGSHAN** was imported directly to England from Langshan, China, by a Major Croad in 1872, just ten years after the Yangtze River was opened to foreign trade. Known in Britain as the Croad Langshan, the bird today has a tall, upright carriage that is distinctive to its breed, yet when Black Langshans first arrived in Britain, some mistook them for Black Cochins. Miss Croad, the Major's daughter, made return trips to China to bring back more birds to solidify the acceptance of this separate breed (though the brown color of the large eggs should have been sufficient to establish the difference). Many communities in China had been very insular, and breeds could sometimes develop quite separately from others that were not far away.

The **LEGHORN** gets its name from Livorno, which is one of a handful of Italian towns that have Anglicized versions of their names. The name Leghorn was also given to a floppy style of hat from Italy, and, because the female chickens had combs that flopped over to one side, the mother of Mr. Acker, the first American to acquire the breed, gave it the name Leghorn. First shipped to the United States in 1874, the Leghorn is a very reliable layer of eggs and is an important element in the makeup of commercial egg-producing hybrids.

The **MALAYSIAN SERAMA** has a jaunty, confident air that is appealing, and the breed, which was developed recently in Malaysia, should grow in popularity. The Japanese is a strong element in the breeding mix, the result being that the Serama's stance is similar to that of the Japanese, with the tail held high, the wings held low next to rather short legs, and the breast thrust out in front of the head.

The very tall **MALAY** is thought to be an ancestor of some of the large Asian breeds, and Malay specimens reached Europe earlier than they did. It is also known to be the ancestor of the Modern Game, and its effectiveness as a fighting bird caused its popularity to spread from the Malay Peninsula into other parts of Southeast Asia.

The cuckoo feather pattern makes the **MARANS** resemble the Dominique of North America, but this breed is from the Marandaise district of France. The birds were introduced to Britain in the 1920s. They mature to a good size, and the breed is valued both for its meat and for its sometimes speckled brown eggs.

The **MINORCA** is a large bird from Spain, specifically from Menorca, the second-largest of the Balearic Islands. The males have an impressive single comb, but the hen's comb falls to one side. For around two hundred years, the Minorcas have been popular in southwest England, the warmest area in Britain, whose ports enjoyed active trade with Spain. The size of Minorca eggs is exceptional. This breed is

KRAAIKOP > CUCKOO **LAKENVELDER** > HEN **LANGSHAN** > BLACK

MALAYSIAN SERAMA > WHITE **LEGHORN** > WHITE

sometimes referred to as the Spanish Red Face to distinguish it from another breed, the Spanish White Face (see below).

As their name suggests, **MODERN GAME** chickens are descended from fighting birds. To some people, the slim silhouette looks wrong for a chicken, but others find it elegant. Further height was introduced via the Malay, but today the Bantam Modern Game is more popular than its full-size counterpart.

The **NAKED NECK**, sometimes called the Transylvanian Naked Neck, is also known as the Turken, as it combines the bare neck of a turkey and the body of a chicken. It comes from eastern Hungary. Though some find the type unattractive, the Naked Necks have a number of practical advantages—they start laying eggs very young and continue to do so throughout the winters; they are also capable foragers and seem virtually immune to disease. Further, the meat is excellent and the feathers pluck easily (some are missing already).

The **NANKIN** is another breed to be named after the port city from which specimens were first shipped to other countries, rather than from its actual place of origin. In spite of the handsome color and the well-balanced proportions, the Nankin is seldom seen at shows.

The **NEW HAMPSHIRE** is a dual-purpose New England breed that has been popular in the state for which it was named since around 1915. The chicks mature very quickly, and the hens are noted for their surprisingly large brown eggs. The feather color is like that of the Nankin, a chestnut red similar to that of chestnut racehorses like Secretariat.

Like the Modern Games, **OLD ENGLISH GAME** birds were once bred for fighting, and their tails would be *docked* (cut short) to eliminate the possibility of an opponent using those feathers as a beak hold. For the same reason, combs and wattles were *dubbed* (trimmed or removed). Some roosters retain an aggressive attitude, and adult males may need to be kept

apart for their own safety. Hens can be fierce in the defense of their chicks. The Old English Game Bantams are extremely popular and include an enormous range of color possibilities. British versions of the Old English Game come in a slightly different style, actually two different styles. Those with a more direct fighting lineage are known as Oxfords and show a sharper angle between the line of the back and the rise of the tail. The Carlisle type has a more horizontal stance and a broader breast; the tail is held lower and has pronounced sickle feathers on either side.

The **RUSSIAN ORLOFF** may have come close to extinction when large exotic birds from eastern Asia became sought after and interest in these previously impressive birds declined. Although bred in Russia for a long time, these birds came originally from Persia (present-day Iran) and also had Malay ancestry.

For a time, Britain produced two similar types of black chickens, but the one developed by William Cook of Orpington in southeast England became the officially recognized breed. Apparently the original **ORPINGTON** breed mix included strains of Langshan, Cochin, Minorca, and Plymouth Rock. When he came up with a Buff Orpington, Mr. Cook was again challenged for the right to qualify a new breed, this time by supporters of the Lincolnshire Buff, but again Mr. Cook prevailed.

While British breeders refined the Orpington to score show points at the expense of utility, Orpingtons taken earlier to Australia were maintained as a practical breed. When some Australian birds reappeared in Europe, they were scorned as coarse and unrefined, and their supporters naturally had little respect for those birds with diminished functional assets. The solution was to create a new name for the Australian version, and so the **AUSTRALORP** was born.

The Dutch **OWLBEARD** has a split or horned comb, which distinguishes it from the otherwise similar Thuringian Bearded Fowl in Germany.

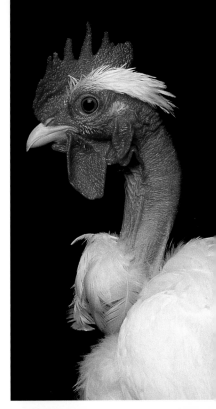
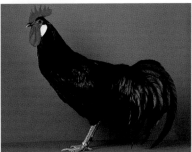
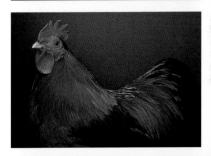
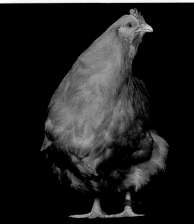

NAKED NECK > WHITE **MINORCA** > BLACK **NEW HAMPSHIRE** **ORPINGTON** > BUFF

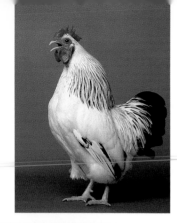

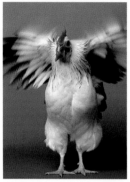

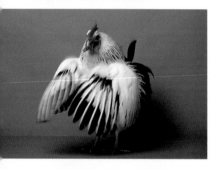

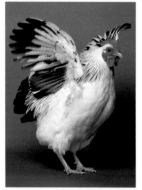

The **PHOENIX**, or Onagadori, is the result of at least four hundred years of breeding to create exceptionally long tails. Sometimes used to decorate a warrior's lance, these feathers were also a matter of prestige to Japanese land-owning aristocrats. Farmers could ingratiate themselves with the master by producing and caring for these spectacular specimens. The birds do not molt, and tail lengths of more than 20 feet are possible; the *Guinness Book of World Records* reports one bird with an amazing tail of 34 feet, 9 ½ inches.

The **PLYMOUTH ROCK** was created in New England in the latter half of the nineteenth century and quickly became a favorite for both farmers and exhibitors. It was equally successful when shipped to Britain in 1879. The breeding mix included Dominique, Cochin, Brahma, Java, Minorca, and Leghorn.

They are known as **POLISH** in the United States and as Poland in Britain, yet the breed is believed to have originated in Italy (in some languages they are called Paduan after that part of Italy) and been brought to its present state of development in Holland (sometimes they are referred to as Crested Dutch). Because they were common in Eastern Europe, these crested birds may well be named for Poland, but there is speculation that the River Po in Italy is the source of the name or that the name refers to the *poll*, an old (Middle English) word defined as "the top of the head." Polish crest feathers grow from a knob or small dome on the top of the skull. The crest feathers are fairly neat and rounded on the females and more extravagant, unkempt, and pointed on males. One might worry about the birds' ability to see where they are going, but the crests do not obstruct their downward vision, the direction they need to look when feeding.

An unusual feature of the **RHINELANDER** is its almost horizontal stance. Although black is the most common color, other versions can be seen occasionally; Bantams also exist. The breed was developed during the 1890s in Germany's Eiffel Mountains, and the Eiffel

Fowl is one of the breeds used to create the Rhinelander. With its thick-set physique, it was conceived as a bird good for both meat production and egg production, with an annual yield of around 180 large white eggs. Rhinelanders are said to be both lively and friendly.

With no full-size counterpart, the **ROSECOMB** is a true Bantam. Its comb ends in a spike, like that of the Hamburg, and the earlobes are a clean white.

The **SCOTS GREY** is, not surprisingly, a hardy bird, able to withstand the cold, wet winters of Scotland. Its long legs help it to move through the rugged landscape in search of food. The breed dates back at least to the sixteenth century, and probably beyond.

SEBRIGHTS are true Bantams with no full-size equivalents. When Sir John Sebright developed the breed nearly two hundred years ago in Britain, he initially arrived at the Golden Sebrights, then used them as a starting point for breeding a Silver version.

The **SHAMO** was a popular fighting bird in Japan for many centuries and is one of the world's oldest breeds. Its ancestor was the Malay. This is a very tall bird, heavy, strong, and agile, and with a suitably pitiless expression.

The shape of the **SICILIAN BUTTERCUP**'s comb is unique. Ideally, it should look rather like a primitive royal crown, cup shaped and symmetrical, with points like those on Lady Liberty's head.

The unique feather structure of the **SILKIE** makes this chicken look more like a fluffy mammal than a bird. Marco Polo was probably referring to Silkies when he wrote of seeing chickens with wool rather than feathers in India and the Far East. Specimens did not reach Europe until the middle of the nineteenth century. The Silkie's earlobes are a light blue, and the color of the comb and wattles has been described as "mulberry."

PLYMOUTH ROCK > COLUMBIAN

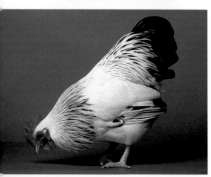

SPANISH WHITE FACE looks as if it belongs at a masked ball or carnival. It is a very old breed, prized for its large white eggs, although it has lost some of its hardiness by being kept indoors to preserve the clean white of the face for show purposes.

SULTANS were first brought from Turkey to England in the 1850s and to the United States about ten years later; they were recognized in the *American Standard* in 1874. One assumes Polish genes, but the vulture hocks and well-feathered feet come from elsewhere. The Sultan had found favor as an ornamental breed in Turkey, but in spite of its striking appearance, it never caught on widely in the rest of the world.

The **SUMATRA** is indeed from the island of Sumatra, but these gregarious birds were capable of flight between there and the island of Java. Locals tended to regard them as pheasants because they show a very horizontal line from the neck to the tail and have a rather pheasant-like head. Used locally as a fighting bird, the first Sumatras to reach America in 1847 were also used that way. It took another fifty years for the breed to appear in Britain. The males often develop complex and unusual spurs.

The **SUSSEX** was bred around a hundred years ago as a utility bird, and, together with the Cornish (Indian Game), it contributes to the hybrid that is the modern supermarket broiler. At the same time, the Sussex has remained popular for small farms and often does well at poultry shows.

Around 1915 Oscar Vorwerk set out to create a buff-colored version of the Lakenvelder, and he naturally included that breed in the mix. The resulting **VORWERK** chickens, particularly the hens, resemble the Buff Columbian Sussex, which was one of the birds in the mix, along with the Orpington and the Andalusian. Other breeds from Belgium and Germany were added to increase egg production, and the end result is a chicken that is sometimes incorrectly referred to as a Golden Lakenvelder. The Vorwerk is about 25 percent larger than the black and white

Lakenvelder. Vorwerks are active birds, and quick to mature.

The **WELSUMMER**, a Dutch breed named for the village of Welsum, lays eggs that have a rich dark brown color, sometimes with spots and speckles.

Named for a Native American tribe in New York State, the **WYANDOTTE** was developed in the second half of the nineteenth century. It was initially the result of a cross between the Cochin and the Silver Sebright. Over time, other breeds have been incorporated in order to manipulate the size and to add other colors and patterns.

Bred in Japan and Korea for hundreds of years, the **YOKOHAMA** has a pheasantlike appearance reminiscent of the Sumatra. The breed first came to Europe in the 1860s, and the Germans became skilled at developing the long tails. Yokohamas weren't officially recognized by the *American Standard* until 1981.

A few final notes: Because this book is not intended as a scholarly or encyclopedic reference, readers might like to know of a few publications that are. Many of the national organizations for poultry enthusiasts around the world publish books giving detailed descriptions of all the recognized breeds. They include a great deal of interesting information, including details about variations in color and feather patterns.

In Britain, the official book is *The British Poultry Standards*, and the country supports two national organizations, The Poultry Club of Great Britain and The National Federal of Poultry Clubs. For the Germans there is the *Deutscher Rassegeflügel Standard* and a national organization, the Bund Rassegeflügel Zughter. In the Netherlands is the Dutch Association for Breeders of Poultry and Waterfowl, and the official book is the *Pluimvee Standaard*. In the United States, the American Poultry Association publishes the *American Standard of Perfection*. The 1998 edition is the eleventh revision since 1953, and this association, like others, is constantly updating its lists with new breeds and varieties as they become recognized officially.

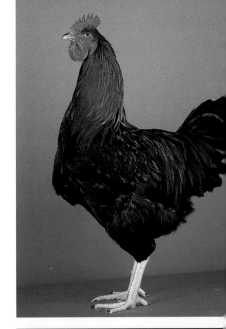

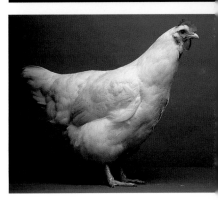

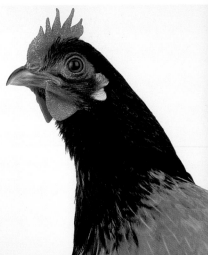

WELSUMMER **RHINELANDER** › BLACK **SUSSEX** › WHITE **VORWERK**

Editor: Harriet Whelchel
Editorial Assistant: Jon Cipriaso
Designer: Helene Silverman
Production Manager: Jane Searle

Library of Congress Cataloging-in-Publication Data

Green-Armytage, Stephen.
 Extra extraordinary chickens / by Stephen Green-Armytage.
 p. cm.
 Follow-up to: Extraordinary chickens. 2000.
 Includes bibliographical references (p.) and index.
 ISBN 978-0-8109-5924-8 (hardcover)
 ISBN 978-0-8109-9247-7 (paperback)
 1. Chicken breeds. 2. Chicken breeds—Pictorial works.
 I. Green-Armytage, Stephen. Extraordinary chickens. II. Title.

 SF487.G655 2005
 636.5'0022'2—dc22

 2005008946

Printed and bound in China
10 9 8 7 6

Abrams books are available at special discounts when purchased in
quantity for premiums and promotions as well as fundraising or educa-
tional use. Special editions can also be created to specification. For
details, contact specialsales@abramsbooks.com or the address below.

ABRAMS
THE ART OF BOOKS SINCE 1949

115 West 18th Street
New York, NY 10011
www.abramsbooks.com

PHOTOGRAPHER'S NOTE

Most of the photographs were taken on Kodachrome film, processed
by Kodak in New Jersey. More recently, film was processed by Dwayne's
Photo in Parsons, Kansas. A small percentage of the pictures were
taken on Ektachrome films, EPN and EPP, and processed by Colortek
in Boston. The cameras I used were usually motor-driven Nikons, and
most of the pictures were taken with the 105-mm Micro-Nikkor lens.
In some cases, particularly with larger birds or with pairs of chickens,
I worked with the 55-mm Micro-Nikkor. My flash equipment consists
of Balcar heads adapted by Flash Clinic in New York to work with
Dyna-Lite power packs. Exposure was determined by Minolta Flash
Meter III, and confirmed by Polaroid color film in an ancient 195 Land
Camera. To ensure accuracy in the colors of the feathers, I avoided
using some of the slide films that are designed to increase saturation.
For the same reason I did not use any filters that might have distorted
color. I have done no digital manipulation, and neither has the art
department at Abrams. However, for a few photographs we asked the
printers to clean up the surfaces on which the birds stood or sat.

page 1: **MODERN GAME**> WHEATEN PULLET

pages 2 and 3: **HAMBURG**> SILVER-SPANGLED HEN

ACKNOWLEDGMENTS

A book like this could not happen without the help and cooperation of a great many people. It is not possible to name all of those who generously allowed me to photograph their wonderful birds, usually handling them for me, and sometimes rustling the few that were adventurous. It is possible, however, to name a few people who were particularly important to this book and to the previous volumes.

My greatest debt is to Hans Schippers, who was so generous with his knowledge, his time, his personal contacts, and even at one point his car, when my rented vehicle had a brief sickness. Hans is a professor emeritus of biology in the Netherlands, and is known around the world as an expert on poultry and other animal subjects, having written countless books and articles, often illustrated with his own fine photographs.

I also want to thank the organizers of chicken shows, people who were very busy but who took the time to make it possible for me to set up my version of a poultry portrait studio: Arlene Sliker and Jo Miller in Sussex County, New Jersey; Joel Henning and Rick Hare in Hamburg, New York; Dave Adkins and Tim and Susan Bowles in Lucasville, Ohio; Sal Lico in Rhinebeck, New York; John Pierce in Syracuse, New York; P. Kroon and A. Bleyenberg in Ede, Holland; David Hacket and Dick Rickets in Stratford-on-Avon; and on two separate visits to Topsfield, Massachusetts, Edie Rochette, Bob Murphy, the late Lorna Rhodes, Brian Knox, and, more recently, Rebecca Buffington and Bob Rhodes.

Although most of my photographs were taken at these shows, I also visited some individual breeders: Rick and Karen Porr in Pennsylvania; Paul Kuhl and his family and Cy Hyde in New Jersey; the late Arie Boland in the Netherlands; and the late John Castagnetti in Massachusetts; John was also helpful with information, advice, and the loan of books. One of the four Jungle Fowl species was photographed at the home of pheasant and waterfowl breeders E.T. and Jan Trader, and they in turn put me in touch with breeders in North Carolina for the others, Don and Ann Butler, and then Andy and Diane Petykowski.

I also took photographs at three other places: the Nederlands Pluimvee Museum, for which I thank Mr. Welling; the Rare Breeds Center in Kent, England, guided by Fred Hams, with whom I had previously had several useful and enjoyable conversations; the Domestic Fowl Trust in Worcestershire, a particularly fruitful day as the guest of Stan Jones and distinguished vet Mrs. Bernie Landshoff.

In addition to assistance from Hans Schippers, I had many helpful conversations, in person and on the telephone, with the following: Loyl Stromberg, the late Lorna Rhodes of the American Poultry Association, Ned Newton, Mike Hatcher, Rudiger Wandelt, and Howard Kogan.

For my initial introduction to ornamental chickens, I need to acknowledge those at *LIFE Magazine* who involved me in a long-ago job to photograph at a great chicken show in California: writer Daphne Hurford and photo directors John Loengard and Mel Scott, for whom I did several animal assignments.

When I showed the *LIFE Magazine* pictures to my publishers at Harry N. Abrams, Inc., they were quick to realize the subject's potential for a fine book, in particular I must credit editor Harriet Whelchel. The first book was designed by Carol Robson, and a small paperback version was designed by Miko McGinty and Rita Jules, and edited by Gail Mandel. For this new book I want to again thank Harriet Whelchel, and now for this handsome design, Helene Silverman.

INDEX OF BREEDS

(Numbers refer to page numbers.)